Cuba

Portrait of an Island

Photographs by Donald Nausbaum

Text by Ron Base

Interlink Books

An imprint of Interlink Publishing Group, Inc.

New York • Northampton

First published in 2005 by
Interlink Books
An imprint of Interlink Publishing Group, Inc.
46 Crosby Street, Northampton, Massachusetts 01060
www.interlinkbooks.com

ISBN 1-56656-579-0

Library of Congress Cataloging-in-Publication Data available

Design by Gary Fielder at AC Design
Cover design by Gary Fielder at AC Design
Map by Peter Harper

To request our complete 40-page full-color catalog, please call us toll
free at 1-800-238-LINK, visit our website at www.interlinkbooks.com,
or send us an e-mail: info@interlinkbooks.com

Printed in Thailand

2009 2008 2007 2006 2005
10 9 8 7 6 5 4 3 2 1

Contents

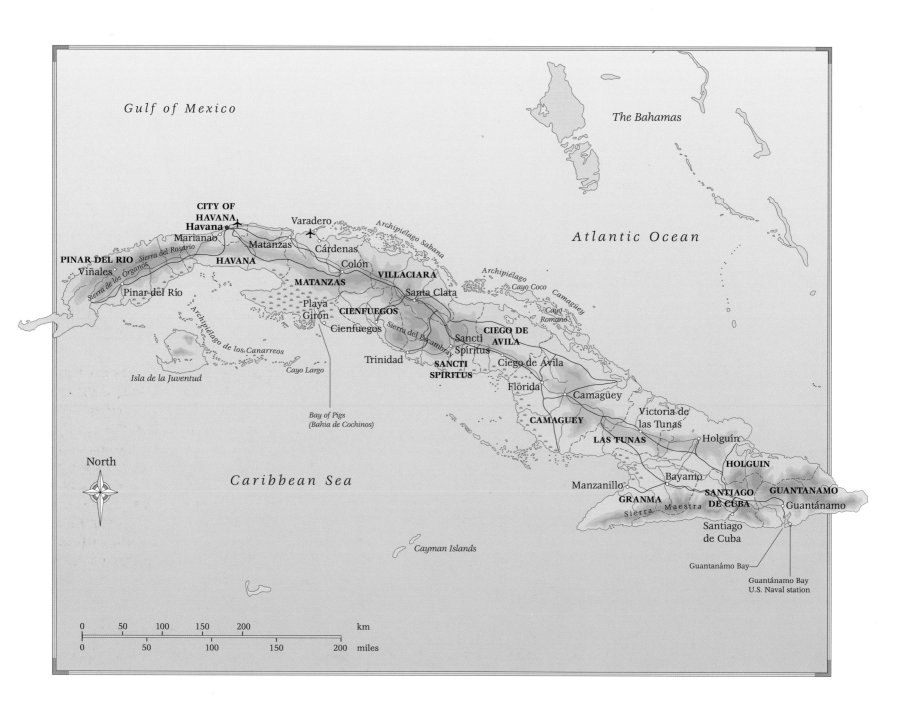

Gulf of Mexico

The Bahamas

Atlantic Ocean

CITY OF HAVANA
Havana
Varadero
Archipiélago Sabana

Marianao
Matanzas

PINAR DEL RIO *Sierra del Rosario*
Cárdenas

Viñales
Colón

HAVANA
VILLACIARA
Archipiélago
Cayo Coco

Sierra de los Órganos
MATANZAS
Santa Clara
Camagüey

Pinar del Río
Cayo
Romano

Playa
Girón
CIENFUEGOS

Archipiélago de los Canarreos
Cienfuegos
Sierra del Escambray
Sancti
Spíritus
CIEGO DE AVILA

Cayo Largo
Trinidad
SANCTI
SPÍRITUS
Ciego de Ávila

Isla de la Juventud
Flórida

Camagüey
Victoria de
las Tunas

Bay of Pigs
(Bahía de Cochinos)
CAMAGUEY

LAS TUNAS
Holguín

Caribbean Sea
HOLGUIN

North
Manzanillo
Bayamo

SANTIAGO
GUANTANAMO

GRANMA
DE CUBA
Guantánamo

Sierra Maestra

Santiago
de Cuba

Cayman Islands

Guantanámo Bay

Guantánamo Bay
U.S. Naval station

| 0 | 50 | 100 | 150 | 200 | | km |
0 50 100 150 200 miles

Introduction

Draw a portrait of an island. Do it in a few strokes, the lines lovely and sensuous like your subject, so that it lodges in the imagination in ways no other place of its size and importance ever does. Give your portrait any other name in the region, say Jamaica or Trinidad or Barbados, and you have tourist destinations. But set out to draw Cuba, and that's a shiver along the spine. Those fine, sumptuous lines you execute are drenched in sunlight but they also exist in shadow, haunted by old ghosts and faded glamour. The ghosts still drive their 1955 Cadillacs along the Malecón late at night, listening for the sound of Frank Sinatra records, the muted thud of dice against green baize, the tinkling laughter of a pretty señorita, the cry of angry young men determined to change things.

Those ghosts will keep asserting themselves in your portrait. You can never shake them. What's more, there's something wrong with those lines you're drawing. Hard to keep them simple, isn't it? Almost by necessity they become more complicated and conflicted. Therefore, they must be carefully unravelled and even then they may not always make sense to the casual observer. Your portrait of Cuba contains so many disparate things, does it not? There is American imperialism at the turn of the century at its most American and imperialistic. There are dictators with Florida bank accounts, gangsters and tourists who must be included, as well as playboys and movie stars in search of a wild time 90 miles from the Florida Keys. And of course, you can't forget Fidel and the Revolution.

The portrait contains everything you wanted it to, yet – and isn't this frustrating? – it still turns out to be nothing like you expected. But that is Cuba. You draw an island, but the island is endless and you cannot find its boundaries. 'I have often wondered what I should do with the rest of my life, and now I know,' Ernest Hemingway wrote in 1928, 'I shall try to reach Cuba.'

So you spend a lifetime reaching Cuba and in the end Cuba leaves you stranded a few miles offshore, exhausted and dreamy, happy and yet curiously depressed. It never stops teasing and seducing, a love affair unrequited. You want to leave Cuba – and you never leave Cuba. Ask anyone who's ever been there. Ask the million Cubans who fled for Florida, but never truly left. Ask Don Nausbaum, the Canadian photographer who took the photographs for this book, who has visited the island 17 times, and who keeps coming back, always drawn back, as though one more picture will finish the portrait. Just one more and he will have Cuba. And yet Cuba remains tantalizingly out of reach.

Or ask me.

I went to Cuba the first time in the early seventies, having grown up steeped in the Cuban Missile Crisis, Hemingway

prose, and Alec Guinness in *Our Man In Havana*. The Revolution was a mere twenty-odd years old. The Russians were in town (with their annual $6 billion in subsidies, and still no one liked them). Fidel, as everyone called him (or *El Egregio* or *El Supremo* or, my favourite, *El Titán*), was rumoured to be nearby. But, then, everywhere you went, Fidel was rumoured to be nearby. You could rent a sprawling beach house at Varadero for next to nothing. The Dupont estate just up the beach stood locked and empty. The only way you could get into Havana was by special tour bus. Minders watched you carefully and became extremely nervous if you wandered off. Hemingway had just left his house, *Finca Vigía* (Lookout Farm) in the suburb of San Francisco de Paula, even though he had been dead for a decade. His ghost, like many ghosts in Cuba, lingered so close. His glasses lay on the bed beside the local papers. His slippers were under the bed. Surely, he would be back in a few moments. We met two young Cuban men on the beach who barely spoke English. They invited us to their mother's place in the Havana suburbs for lunch. A dozen people must have gathered in the tiny one-storey house, friendly, intensely curious. They found us very exotic after years of no contact with outsiders. We certainly found them the same way. They caught a chicken in the back yard, killed it, and roasted it for the meal. We suspected this was the last good meal they would have for a month. Everyone expressed amazement we were all together like this. But everyone laughed and talked, even though commonality of language was at a premium. The warmth of our hosts that long afternoon was contagious enough to survive in memory 30 years later.

When I returned after many years, much had changed although, as everyone says of Cuba, nothing had changed. The beach houses are gone, and Varadero, that eleven-mile-long sand spit, is the premier vacation destination (from which most Cubans are excluded), choc-a-bloc with vast tourist hotels built by the Spanish and Germans and Canadians (30,000 rooms and growing, providing two billion annually in much needed American dollars). The Dupont estate is now a golf course, and you can have a drink at the top of the house with a great view of the peninsula. These days you can easily rent a car to go into Havana, and stay at a hotel in the city, and no one looks twice at you. Hemingway's ghost no longer seems to linger so close. The glasses no longer are on the bed, and there is no sign of the slippers.

The Russians have long since departed, not nearly as fondly remembered as Hemingway. All that's left of them are the moving wrecks that are Soviet-made Ladas and Volgas, battered and dented boxes that constitute one of the few signs that the country has moved on since 1959, the date of the Revolution, the point at which all the clocks stopped and time began standing still here. The young men who invited us to their mother's home all those years ago would be middle-aged now. Because the transportation system is so unreliable, everyone hitch-hikes, and everyone who drives picks up hitch-hikers (and everyone with a car quickly becomes a *de facto* taxi driver, accepting a few pesos for providing a ride). When you pick up passengers at the beginning of the twenty-first century, you hear the same complaints as those two young men expressed three decades ago. The Revolution endures; the grumbling continues.

The reality of daily life remains much the same as it has since 1959. *'No es fácil,'* - 'it isn't easy' – remains the commonly heard catch phrase. The *gringo* journalists who descend on the island from time to time to lament the sorry state and failed promise of Castro's revolution quickly pick it up. There is little doubt the country has had to endure many hardships, but, it could be asked, what country in the area hasn't? The grinding, brutal poverty found in places like Jamaica and Haiti, Mexico and Brazil, where the 'haves' have so much and the 'have nots' have nothing at all, has not replicated itself in Cuba. The gentrified élite do not drive past in their Mercedes with their Prada shopping bags on the way back to gated and guarded hilltop mansions, as happens in so many other Latin countries. For all its difficulties, there remains a lively dignity about Cuba, even at its poorest. In a world largely branded to death by the demands of global commerce, those demands and their brands have not yet arrived on the island. The branding, such as it is, comes in the colours of the Cuban flag, red, white and blue. The billboards are devoted not to Benetton but to revolutionary exhortations: *'No al Bloqueo'* ('No to the blockade'); *'Por la Vida'* ('For life!').

Still, capitalism, like the salt air in Havana that eats away at the city's old colonial buildings, slowly shifts the structure of Cuban society. Those shifts accelerated – what passes for acceleration in Cuba – between 1989 and 1992 when Cuba lost 70 per cent of its imports and exports in the aftermath of the Soviet collapse. The promise of a class-free egalitarian society began to come into contact with the harsh realities of

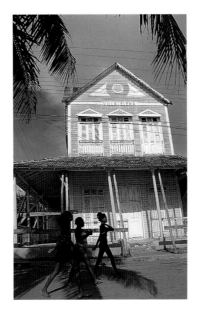

day-to-day survival. Fidel was forced to declare in 1991 a 'Special Period in Time of Peace,' a nice way of saying that tremendous cutbacks were to be implemented. People went hungry for the first time since the Revolution, and cases of malnutrition were reported. Private cars largely disappeared from the streets, and even soap and toothpaste became difficult to acquire.

Since that time the situation has eased, but there remain shortages. Cubans receive a basic food ration in accordance with the number of people in a family, and their ages. In a nation of coffee lovers, even the coffee is rationed. Everyone does receive bread each day; it resembles a hamburger bun - our daily bread, it is joked – a staple of Cuban life.

The average educated person earns the equivalent of $15 US (300 Cuban pesos) a month, terribly low in a country with 80 per cent literacy and where just about everyone you meet appears to have a university education. Still, things cost very little, so prices are generally affordable – if merchandise is available, always problematic in today's Cuba. Fail to show up at your neighbourhood *bodega* (local shop) on the right day of the month and you miss out on such staples as rice, sugar, and beans. Just to be sure, people check their *bodega* each day (meat and eggs can appear on unexpected days of the month). A Cuban shopper must be patient and dedicated and be willing to make many visits – a bakery for bread, agricultural market for vegetables, and the *bodega* for dry goods. People augment their shopping by trading and swapping for any essentials they need but lack.

In 1993 the societal shift became even more dramatic when the state finally made it legal for citizens to hold American dollars. Previously, you went to prison for such a thing. People with families overseas could have relatives send them money. In 1995 Cuban expatriates were allowed by President Clinton to return once a year for humanitarian reasons. That opened up the floodgates from Miami, bringing in more American dollars. It's estimated that relatives living outside Cuba send a billion dollars annually to the island.

And here's where the new paradox of Cuban life asserted itself: the inflow of American dollars induced the Cuban government to re-introduce private enterprise into an economy that had assiduously rejected it for more than three decades. In other words, capitalism, which had driven the island's economy for so many years, was back.

Granted, it was baby capitalism, but it included the opening of special stores for Cubans with American dollars. At *agromercados*, for example, customers can buy vegetables at any time, but they are expensive. A pound of pork can run to 25 pesos, this in a country where an average monthly salary is usually no more than 300 pesos.

While the Mercedes-driving Prada-rich of other Latin countries have yet to show themselves on the streets of Havana, the introduction of free enterprise has created the beginnings of a three-tiered society: those who live off pesos; those who have some dollar income; and the new rich, who are self-employed or who are tied to the power structure in some way.

Most Cubans remain on a so-called peso income. They include, ironically, the country's most and least educated citizens, from doctors, lawyers, professors, economists, journalists, artists, and musicians to factory workers and sugar cane cutters.

The so-called dollar jobs are found in tourism, embassies, and in joint venture capital firms (the Spanish have invested in hotels; Mexicans in telephones and cement, while Canadians are into mining and tourism). Tourism jobs mean tips and access to foreigners. English is a way into these jobs, but so is a spotless record with the Revolution. *Cuenta propia* – self-employment – takes many different forms. Operate a restaurant, drive a taxi, repair bikes and cars, create woodcarvings or sell food and drink on the street. One of the most popular private enterprises are the *casas particulares*, private homes that are licensed to provide accommodation to paying guests, not unlike a bed and breakfast in North America. Also very popular – because they can be so profitable in a country starved for food and nightlife – are state-licensed private restaurants called *paladares* (named for the heroine of a Brazilian soap opera popular when the restaurants began to open). A successful *paladar* catering to tourists can make $500 a night – a fortune in Cuba. In fact, they have become such a staple of Havana nightlife that *The New York Times* even sent one of its food critics to review the best known of them. (Simple is best, cautioned *The Times*, although the critic was impressed with the prices, 15 to 20 U.S. dollars accompanied by drinkable Chilean wine.)

Those who have these coveted dollar jobs must pay taxes and avoid what is euphemistically described as illicit enrichment – that is they must not make too much money. What's more, there are all sorts of rules to be followed, and artfully bent. Much business is done *bajo la mesa*, under the table. In the private restaurants no more than twelve seats are

allowed. The owner can only employ relatives, and rather bizarrely, no shellfish can be listed on the menu. As you might expect there are all sorts of interesting ways to get around these restrictions, including the offering of the shellfish off the menu. Still, owners must be careful: an infraction of the rules brings a 1,000 peso fine.

There has always been a great *sandunga* on this island, great flare, and liveliness. But it tends to hide the darker side of the Cuban soul. The Spanish held Cuba in virtual slavery, replaced by the Americans who occupied the country in various ways more or less until 1959. Then it was the turn of the Russians, and now, once again, the seductive dance with America, and all things American. This historic reliance on the kindness of strangers has induced a kind of disillusionment that the Cubans call *choteo criollo*. As a people they try to pretend there is no unpleasantness. They look the other way, and because they do, the most unlikely characters show up on their doorsteps wanting to tell them what to do.

Christopher Columbus, Cuba's first tourist, like everyone who would come after him, loved the island. Talking to the Indians he encountered when he landed, he discovered they called the place 'Cuba'. It sounded good to him, and so he wrote back to his employers, the king and queen of Spain, that this Cuba was 'of such marvellous beauty that it surpasses all others in charm and graces as the day doth the night in lustre'. By 1762, Havana was a city of 40,000 (larger than either New York or Boston) and under siege by a British fleet. The British took the port from the Spanish, thus adding the island to such recent acquisitions as the New World and India. After importing large numbers of slaves from Africa in order to bolster the booming sugar cane trade, the British departed less than a year later when England, Spain and France made peace. With the Spanish back, and lots of slaves in place to do the backbreaking work, Cuba's sugar trade boomed. By 1820, Cuba had become the richest colony and the world's largest sugar producer. By now, the British had outlawed the slave trade, although Cuba's prosperity continued to rest heavily on the shoulders of the men and women brought to its shores in chains (between 1821 and 1831 more than 300 ships brought 60,000 slaves into the country). The slave merchants in turn reinvested their fortunes in sugar. Those same merchants soon began to see annexation with the United States as the best way to preserve slavery in an increasingly anti-slavery world. The U.S., for its part, was barely a country before it started casting covetous eyes on the island's riches. It was, as the Americans liked to point out, closer to the U.S. mainland than, say, the island of Corsica was to France. The American Civil War brought an end to U.S. slavery, while changing times (even the Spanish stopped turning a blind eye to the practice) and changing economics (development of a centrifugal machine used in sugar cane made human labour bad business) finally signalled the beginning of the end of the slave trade. In the meantime, the Americans developed the idea of 'Manifest Destiny' a highly convenient view that had them as superior Anglo-Saxon beings destined to swallow their

5

neighbours. Manifest Destiny was to take many forms over the next couple of centuries, but never quite go away. However, even as Americans dreamed of making Cuba another state in the Union, many Cubans began to seriously consider the idea of their own independence.

In 1868, a lawyer and anti-Spanish activist, Carlos Manuel de Céspedes, announced, 'The power of Spain is decrepit and worm-eaten.' He became known as Cuba's Abraham Lincoln after he freed his slaves and issued the historic 'grito de Yara', proclaiming Cuba's independence ('We only want to be free and equal, as the Creator intended all mankind to be'). The ensuing War of Independence staggered on for ten years. The rebels were able to keep going largely thanks to the tactics of a brilliant young general, Antonio Maceo who, despite being constantly outnumbered, managed to beat the Spanish armies at every turn. The war finally petered out in 1878 with the rebels accepting Spanish peace terms that included an end to slavery. Meanwhile, from exile, Antonio Maceo rightly argued that nothing had really changed, that the Spanish were still in charge of Cuban destiny. This led to what is generally considered to be the second great uprising in 1895, led by José Martí, founder of the Cuban Revolutionary Party. A doctor of philosophy (as well as a dramatist, novelist, poet, school teacher, and journalist), Martí had been writing and arguing for Cuban independence since the Spanish jailed him at the age of 17. Less than three months after returning to Cuba from his New York exile, Martí died on the battlefield at the age of 42, but the uprising he started carried on. In December, Antonio Maceo, having out-fought the Spanish most of his life, suffering twenty-four wounds in the process, finally succumbed to the twenty-fifth, at the Battle of Punta Brava in Western Cuba. Despite these losses, the rebels were beating the Spanish.

In the U.S., where there had been little interest in seeing the rebels defeat the Spanish in either of the two civil wars, President McKinley steadfastly refused to recognize Cuban independence. The next year, however, the U.S. battleship *Maine* blew up in Havana harbour – the Spanish were blamed, and the Americans entered the war (many years later, it was finally established that the *Maine* exploded as the result of an accident, not due to any act of sabotage).

What followed next became the Spanish-American War. In what turned out to be the only major battle fought by the U.S., 3,000 American troops overran 700 Spaniards at San Juan Hill outside the south-eastern coastal city of Santiago de Cuba. Led by future president Theodore Roosevelt, the assault was immediately refashioned into a piece of heroic American folklore, omitting any Cuban participation. Nonetheless, the expulsion of the Spanish did usher in a period of stability, under the watchful eye of the Americans who quantified their continued participation in Cuban life with the Platt Amendment. Among other things, the amendment gave the U.S. access to Guantánamo Bay (thereby creating enmity that continues to this day). The American military took over control of the island for another two-year period in 1909, a year after the election of President José Miguel Gómez. Nicknamed 'the shark', it was Gómez who opened the way for the kind of wholesale government corruption that became a Cuban tradition until Castro took over. Gerardo Machado elevated the level of corruption to new heights after he became president in 1925. A former cattle thief, and man-about-Havana, Machado by 1928 had installed himself as dictator. He murdered anyone who got in his way, including students and unionists. During Machado's time, prohibition raged in the U.S., and thus Havana became a convenient playground for Americans wishing to escape the

restrictions of life back home. Not only could you drink legally, but you could also gamble, stay up all night and indulge yourself in the sort of sexual escapades that were barely mentioned, let alone tolerated, in the prim American society of the era.

Machado hung on until 1933, when a general strike finally drove him from office. By now, the Americans had their eye on a new strongman, a young army sergeant who led a brief uprising known as 'the revolt of the sergeants'. With a nod and a wink from the U.S., Fulgencio Batista, the son of a sugar worker from the northeast, was able to pull the strings attached to a number of puppet presidents for the next decade. Himself a former sugar cane cutter who joined the army as a private at the age of 20, Batista eagerly continued the tradition begun by his predecessors of not only raking off much of the island's wealth for himself, but also killing anyone who objected to the way he did business. And the way he now did business also included dealings with American organized crime. Most notable among his gangster cronies was Meyer Lansky with whom Batista maintained a friendship for 30 years. (Lansky's Hotel Nacional in 1946 featured Frank Sinatra out front making his Cuban debut while in the back a mob summit decided to murder Los Angeles gangster Bugsy Siegel.)

By 1952, Batista had been out of power once and then back in again (after a coup). Corruption was more rampant than ever. A certain young lawyer had had enough. On July 26 of that year, the lawyer, Fidel Alejandro Castro Ruz by name, led an attack on the Moncada military barracks at Santiago de Cuba. The son of a wealthy planter, educated at one of Havana's most exclusive Catholic schools, Castro's only claim to fame was that he had been named Cuba's best high school athlete in 1944. The attack failed utterly. Batista's first mistake with Castro was his failure to kill him (nearly half the 100 rebels were tortured to death). Instead he was tried, convicted ('Sentence me, it does not matter,' he cried. 'History will absolve me!') and sentenced to 15 years at the Isle of Pines prison. Batista's second and even bigger mistake was releasing the rebels during a general amnesty in 1955. Castro and his brother Raul soon returned from Mexican exile with 81 followers on board a leaky yacht called the *Granma*. Ambushed by the army almost as soon as they landed, 16 survivors including Fidel and Raul escaped into the Sierra Maestra mountains where they regrouped a rag-tag band that included the Argentine-born Ernesto 'Che' Guevara, 26 when Castro met him, and a medical graduate of the University of Buenos Aires. Che believed Castro possessed the characteristics of a great leader, a romantic adventurer who was willing to risk death for a noble cause. It was Che who led the rebels into Havana as Batista escaped the city on the morning of January 1, 1959.

Castro has been in power ever since, the longest serving head of government in the post-war history of the world. He has survived the Bay of Pigs (the CIA-orchestrated attempt to overthrow his government); the 1962 Cuban Missile Crisis (the Russians secretly installed nuclear missiles pointed at the

U.S.); and various assassination attempts (again, CIA orchestrated). His regime also endured the U.S. economic embargo imposed in 1960 which cut off imports and exports (diplomatic relations ended the following year), and the collapse of worldwide Communism in 1991.

Of the puppet states under Soviet domination only Cuba emerged unchanged. Yet one truly historic difference did come out of the end of the Soviet influence: for the first time Cuba found itself truly on its own. The country's heroes would be delighted. José Martí fought against the Spanish, but feared living with 'the monster' that was the United States. Now both are gone. It cannot be argued that Castro has brought to Cubans a sense of national pride – a *Cubanismo* that would have thrilled Martí and Maceo and the other fighters for an independent Cuba. The price of this national pride remains the Revolution. It continues to control everything, and watch over everyone. Fidel is in the air, not always visible, but never far away.

The novelist Henry James observed of Venice, Italy, that there is nothing new to be said, and in fact it will be a sad day when there is something new to say. I'm selfish enough to think the same of Cuba. For the outsider to the island, there is something oddly reassuring about this still life portrait of a country, its lines delicately but boldly fixed. Still, one must be realistic and understand that the portrait reflects a certain selfishness, and is, in the end, impossible. The world crowds at Cuba's doorstep; it will not be long kept away, no matter what happens to Castro and his government. For the moment, though, even as the island slips deeper into the twenty-first century, Cuba endures, much as it historically has endured, not always well, but always the Cuba of lost eras and lost memories – found again, however fleetingly.

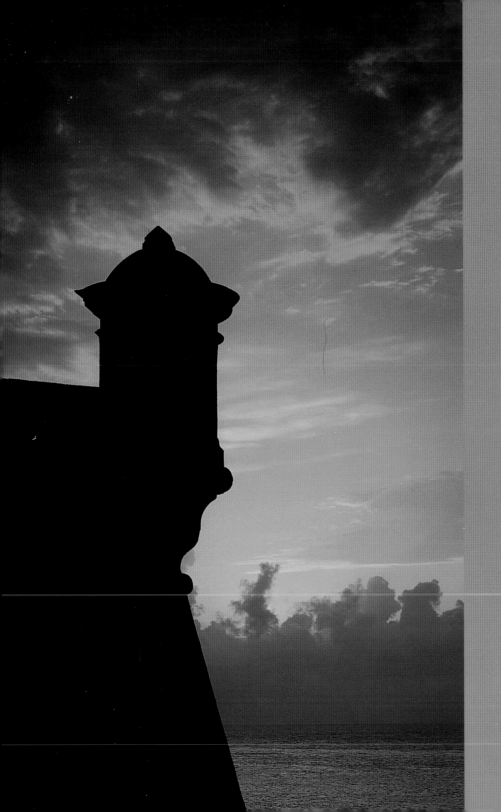

Cuba

Portrait of an Island

1

Havana

vibrant city of elegant decay

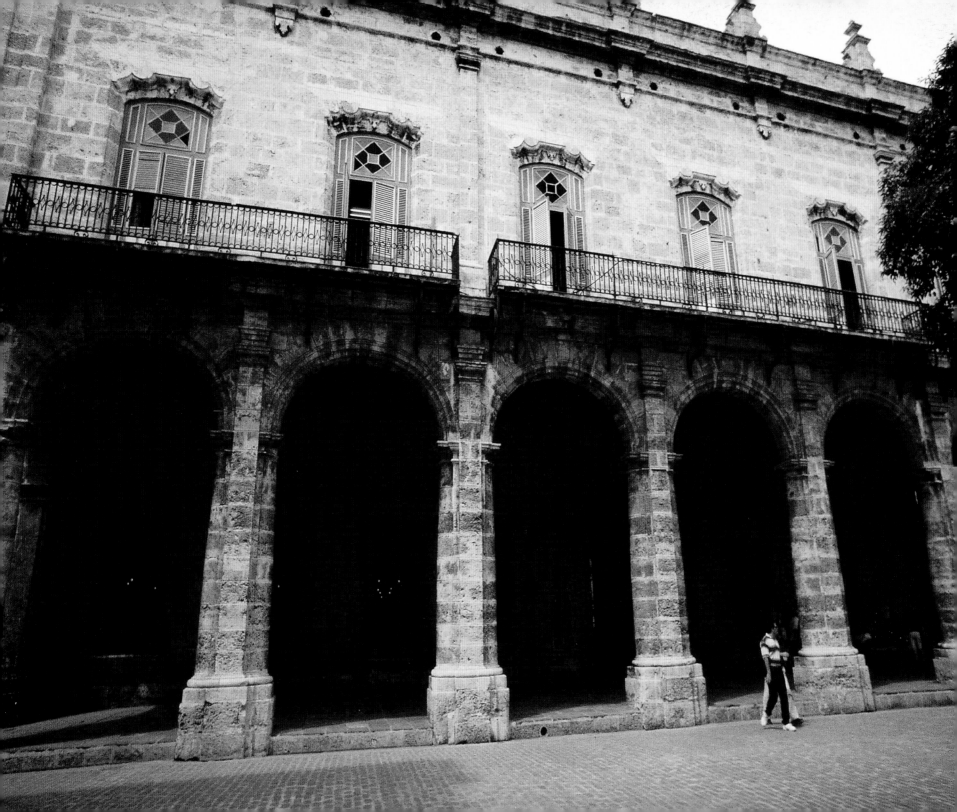

Facing page: The porticoes and balconies of the Palacio del Marqués de Arcos in the Plaza de la Catedral date from the mid-18th century. Originally a private mansion, it later became a post office, and then an art school. Today, it houses a graphics workshop and gallery.

Whatever hardships have befallen it, Havana remains one of the great world cities, all the more so because most of the world has forgotten it exists. Havana is your little secret. The clichés about it as the Paris of the Caribbean are as true now as they were the first time you heard them a long time ago, except Paris lacks the haunted, ruined pallor adopted by Havana through years of neglect. She – and Havana can only be a woman – is like a movie queen of legendary glamour fallen on hard times, Gloria Swanson in *Sunset Boulevard*, the dowager silent star left stranded by changing times, fighting to maintain her faded dignity, and somehow stronger for it. That's Havana.

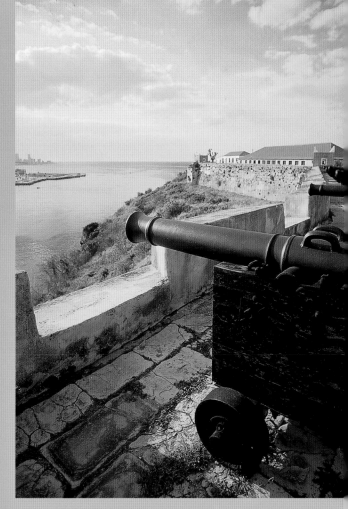

As soon as the Spanish regained Havana from the English in 1763, they decided more fortifications were needed and quickly built Fortaleza de San Carlos de la Cabaña overlooking the harbour just south of Morro Castle. Since the English had come from the east against the unsuspecting Spanish, the new fort was constructed with guns facing east. The English never came back. The guns were never used.

Neglect and disrepair have turned most of Central Havana's charming residences into a crumbling reminder of the city's past grandeur.

11

The imposing Catedral de San Cristóbal, completed in 1777 by the Jesuits, who had begun construction in 1748. The Jesuits had to halt work because the Spanish threw them out of the country. To celebrate their return, they finished the cathedral.

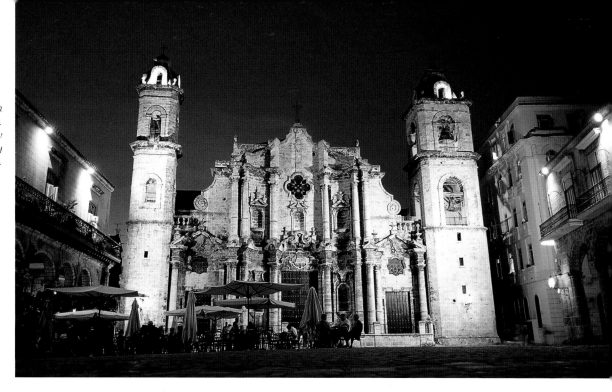

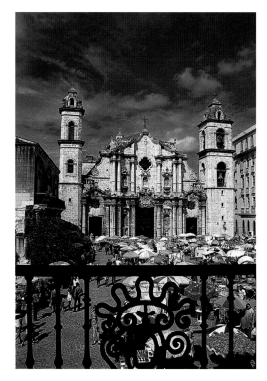

There is some doubt about how often novelist Ernest Hemingway actually visited La Bodeguita del Medio (he was much more likely to show up at El Floridita), but even without him, it is one of Havana's most famous restaurants, and the home of the 'mojito', a rum drink made with fresh mint.

The Plaza de la Catedral is one of the loveliest squares to be found anywhere in the world, so it's hard to imagine this was once swamp land that flooded during the rainy season and thus was known as the Square of the Swamp.

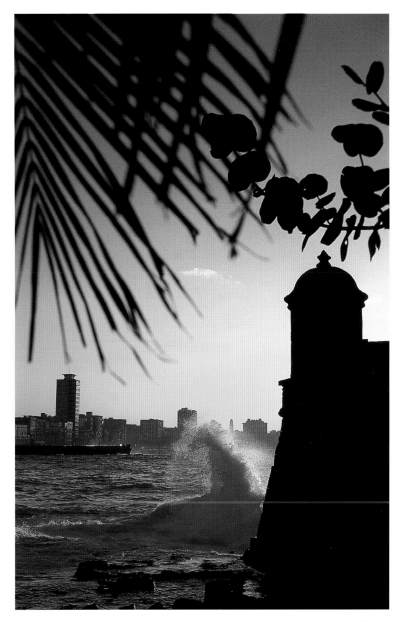

The Malecón, visible across the bay from El Morro (Castillo de los Tres Reyes del Morro). A Havana landmark perched atop a rocky outcropping, El Morro was built in tandem with San Salvador de la Punta Castle across the way. The two forts were designed to protect the narrow harbour entrance. Started in 1589, El Morro took 41 years to construct.

13

Baseball or pelota *as it is called here, in Guanabo, a seaside village outside Havana.*

A couple near their home in Central Havana.

Founded in approximately 1514, the city became the island's capital in 1607 (Havana, or *La Habana* as it is called in Spanish, signifies a treeless plain). As soon as that happened, the corruption that was to be endemic to the city administration for the next four centuries appeared. That corruption fuelled the construction of great mansions complete with red tile roofs, lovely courtyards, and Mudéjar ceilings. The mansions were inhabited by a ruling class of *habaneros* who ostracized the rest of the country, thereby creating an enmity that continued until the Revolution. Havana fell into decline toward the end of the nineteenth century only to be revitalized in the early years of the twentieth century by an influx of American capital. The American *nouveau riche* built their mansions to the west in the Vedado area, and that started the long, slow fade of *La Habana Vieja*, the Old Town. Cuban heat, lack of proper maintenance, as well as humidity, the salt air, and finally and most insidiously, termites, took their toll. In 1982, however, the old city was designated a World Heritage site by UNESCO. That didn't change much for a long time. While UNESCO provided great plans, there was little actual money for any restoration until a scholar and Communist party member named Eusebio Leal Spengler took over and shook things up with his dynamism and willingness to play the capitalist game. It did not hurt that in addition to vastly enjoying the spotlight, Leal was also a good friend of Fidel. He single-handedly pushed forward the restoration of the old city, using partnerships with foreign companies to raise funds. Five hotels opened in the area in 1999.

14

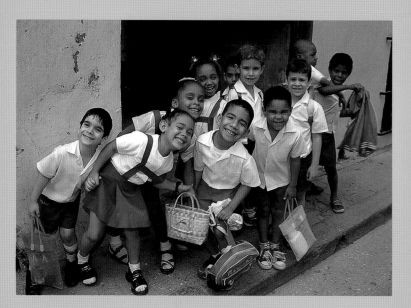

School children on a street in Old Havana.

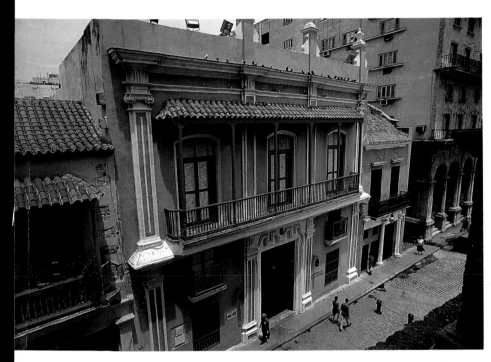

Restored colonial houses near the Plaza de San Francisco.

Instant photography, Cuban-style, on the steps of the Capitolio.

The area surrounding the Plaza de Armas has some of the finest colonial architecture to be found in Cuba.

Depending on your level of patience, these Havana street hustlers are either part of the local colour or a constant and unavoidable impediment to getting around in the city.

15

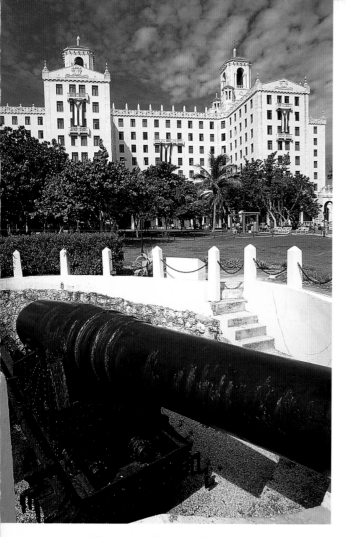

The façade of the Panadería de San José on Calle Obispo, Havana's main street.

The manicured lawns of the Hotel Nacional are pockmarked with protective battlements built by the Spanish. Wandering around, you can still see signs of what made it Cuba's most elegant hotel when it was built in 1930. It became infamous during the 1950s when the American gangster Meyer Lansky owned the place and its casino attracted high-rolling gamblers.

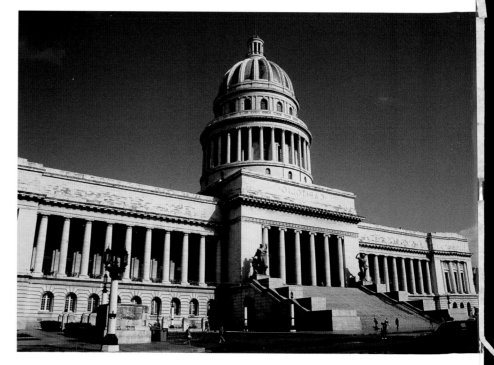

El Capitolio Nacional, with its 300-foot-high dome, was begun in 1910, modelled after the U.S. Capitol building in Washington, D.C. Finally completed in 1929, ironically during the dictatorship of Gerardo Machado, the building served as the seat of the Cuban parliament and the centre of political power on the island until the Revolution. Today it houses the Ministry of Science, Technology and the Environment.

The Old Town can be deceiving, however. It appears so vibrant and alive that you believe the entire city is like this. But it is not. A lethargy pervades much of life around the Soviet-era apartment buildings and on the buses, nick-named camels, trailer-like beasts that are towed around by foul-smelling diesel trucks. Yet not even Havana's grimmer aspects can shake your deep affection for the old star or interfere with her washed-out glamour. Take a drive along the Malecón at night (careful not to make an illegal left turn driving west; the police love to ticket the unwary motorist). Stroll the faded but still elegant Paseo de Martí or Prado to the Capitolio Nacional (completed during the presidency of Gerardo Machado in 1929 and designed as a rather disconcerting replica of Washington's own Capitol building). Pay your respects to the life-size bronze statue of John Lennon (yes, *that* John Lennon, not exactly a regular visitor here, but Cubans love Beatles music). Visit the

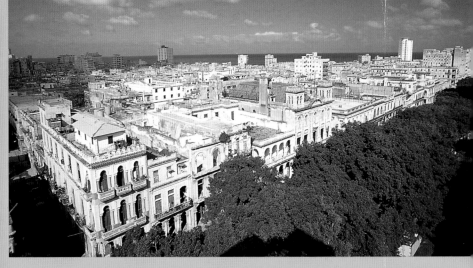

The tree-lined Prado, once one of Havana's finest streets, connects Parque Central to the Malecón and the sea.

Callejón de Hamel area of Central Havana to view the incredible murals of the artist Salvador González, spread over two full blocks, a unique monument to Afro-Cuban culture. These are among the things that keep the love affair alive. Others include the Old City itself, a daiquiri at El Floridita, an afternoon meeting in the lovely old lobby of the Hotel Ambos Mundos, where Hemingway is said to have written *A Farewell To Arms* and part of *For Whom The Bell Tolls*.

You have, after all, travelled a lifetime and made many mistakes, but at the end of a day here, seated in a rooftop restaurant with a view of the city at sunset, you can take solace from the fact that, of all your mistakes, the one you did not make was the mistake of missing Havana.

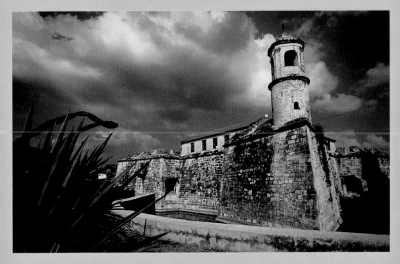

The Spanish fortress, El Castillo de la Real Fuerza, dates from the 16th century.

17

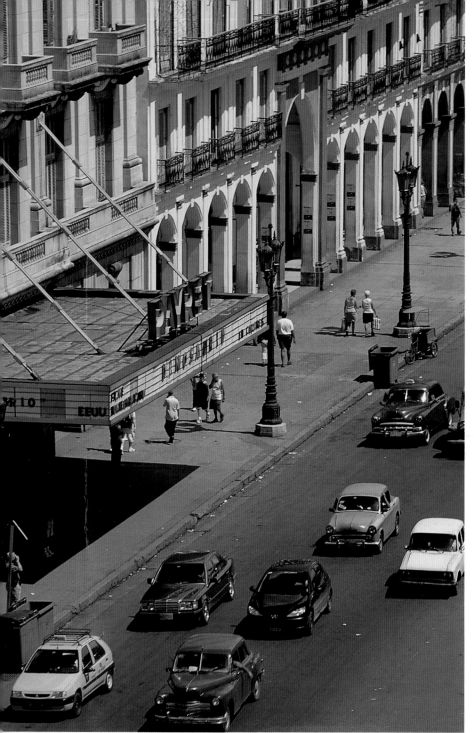

The Fountain of the Lions was sculpted in 1836. It is located in the Plaza de San Francisco.

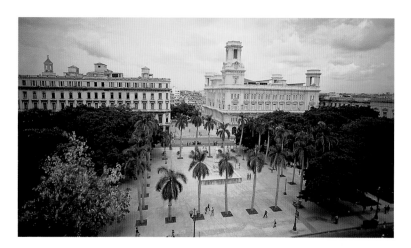

Parque Central and a statue of Cuban hero, José Martí. The park as it is known today was configured in 1877, replacing three open squares. It's a popular gathering place for both tourists and habaneros.

Old colonnaded buildings facing the Capitolio. The street along here is probably the best area in which to see vintage autos.

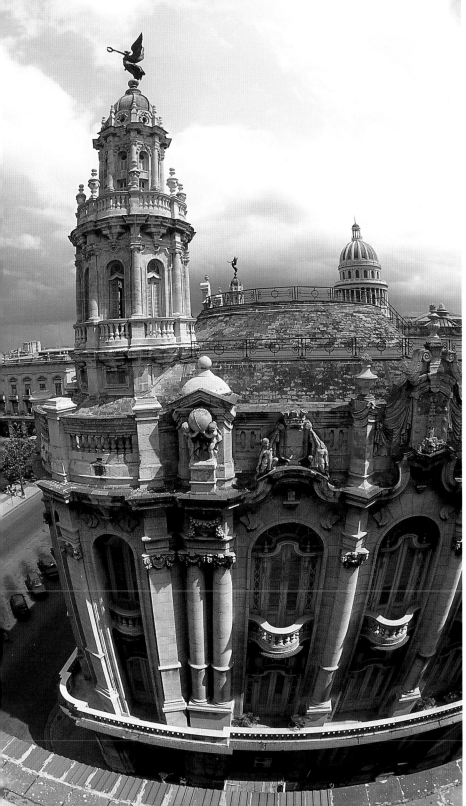

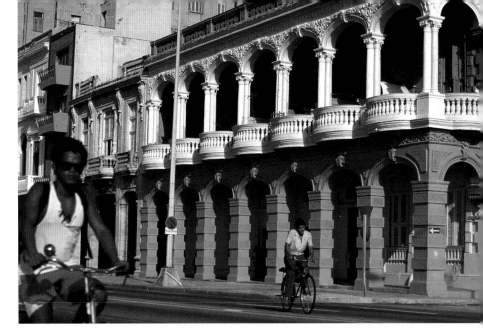

Multicoloured buildings along the Malecón.

A grizzled vegetable vendor sells his produce in the Old Town of Central Havana.

View from the Hotel Inglaterra rooftop looking out at the buildings lining Parque Central.

19

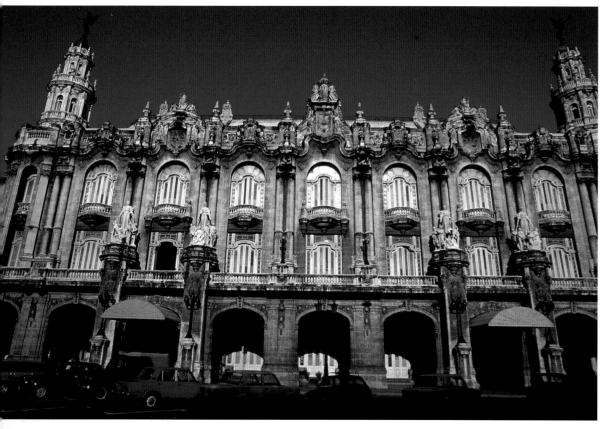

The fantastic neo-Renaissance Teatro Federico García Lorca.

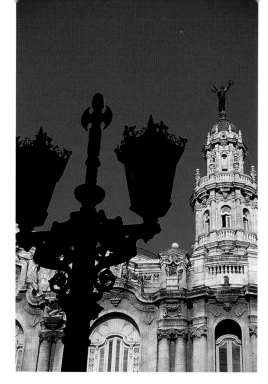

Teatro Federico García Lorca, across from Parque Central, is a neo-baroque building originally constructed in 1834 and known as the Teatro Tacón. It was subsequently renamed and now houses Cuba's National Ballet Company.

Balcony of the Teatro Federico García Lorca.

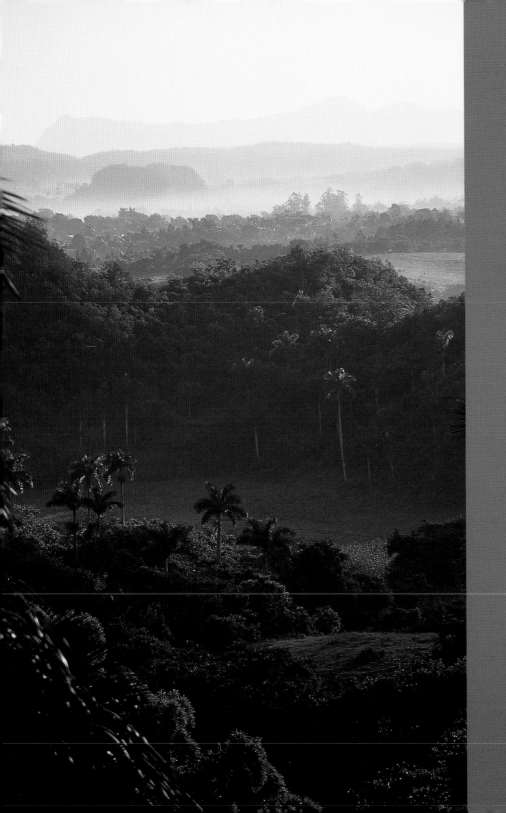

Cuba
Portrait of an Island

2
Viñales

mogotes *and misty valleys*

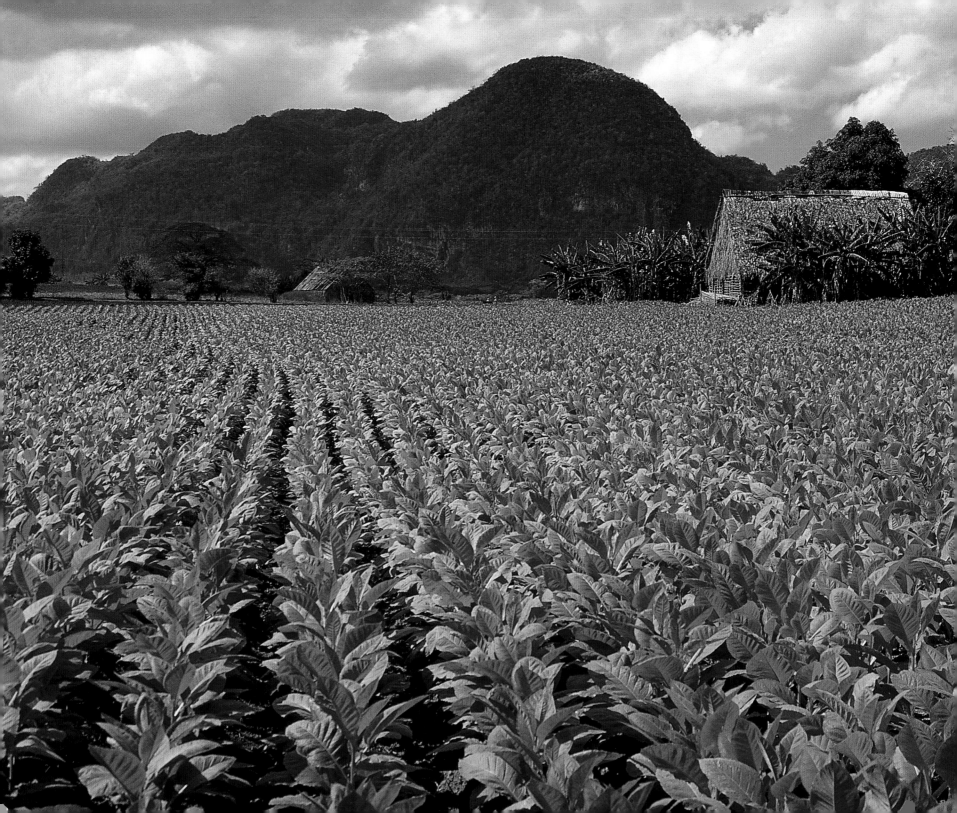

Viñales is the loveliest old town in Cuba. This is due in part to the timeless quality of its main square and the one-storey red-roofed houses one passes on the way into town. It's also due to its setting, nestled as it is in the Valle de Viñales, surrounded by two mountain ranges, the Sierra de los Órganos and the Sierra del Rosario.

Caïman oaks, kapoks, and Sierra palms are among the forms of vegetation that flourish on the mogotes.

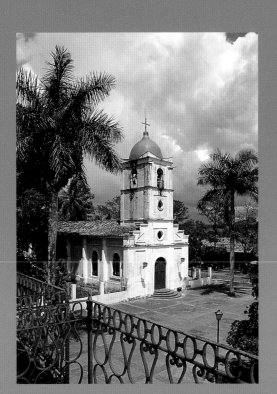

The church in the main square of Viñales.

What makes the area particularly memorable is the presence of a line of sugarloaf-shaped hills known as *mogotes*. These formations, the result of millions of years of erosion by underground streams, are the oldest in Cuba, dating back 150 million years, and are filled with fossils.

Viñales itself is so beautiful it has been turned into a national monument. The town was founded in the nineteenth century as tobacco farms expanded in the region. Today most of the tobacco grown around here is used for locally produced cigarettes, and is not exported. A few miles from the town, the life of the *campesino* goes on much as it always has. Tobacco is grown between January and April. After the tobacco is harvested, the farmers turn to the cultivation of corn and beans.

23

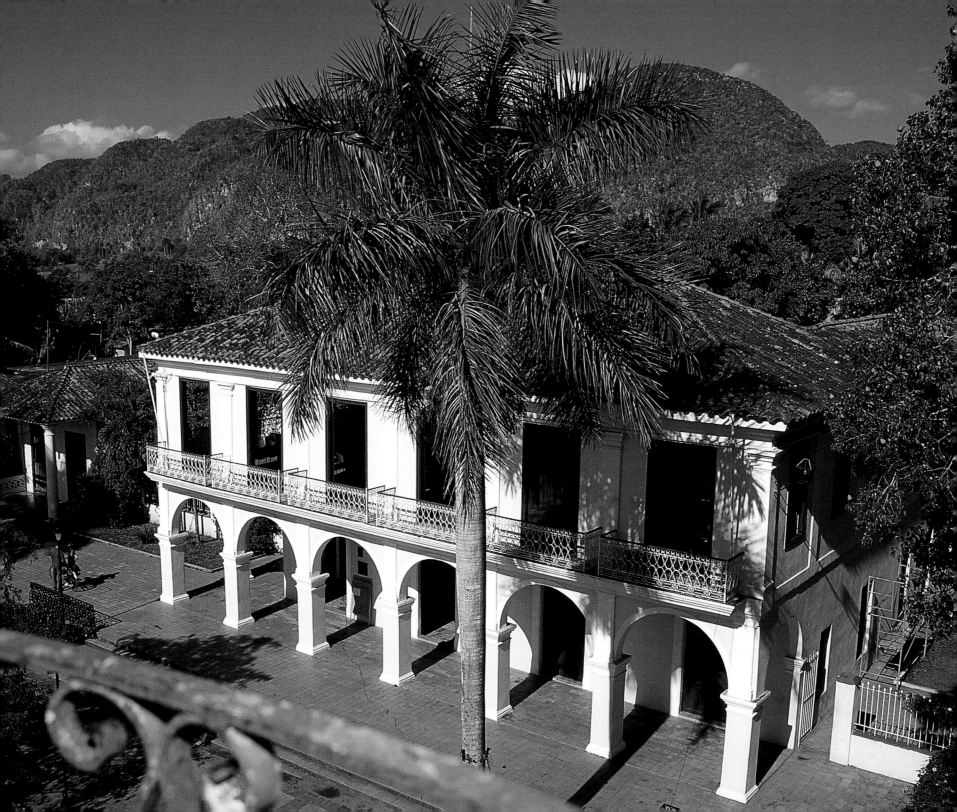

Facing page: The view from the bell tower looking onto Plaza Martí.

Cast iron bell in the town's church.

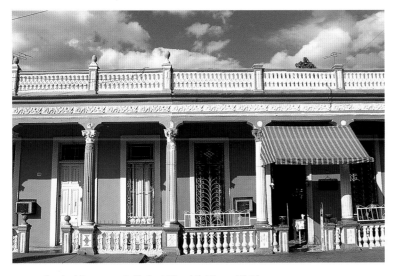

A neo-classical house on Calle José Martí in Pinar del Río.

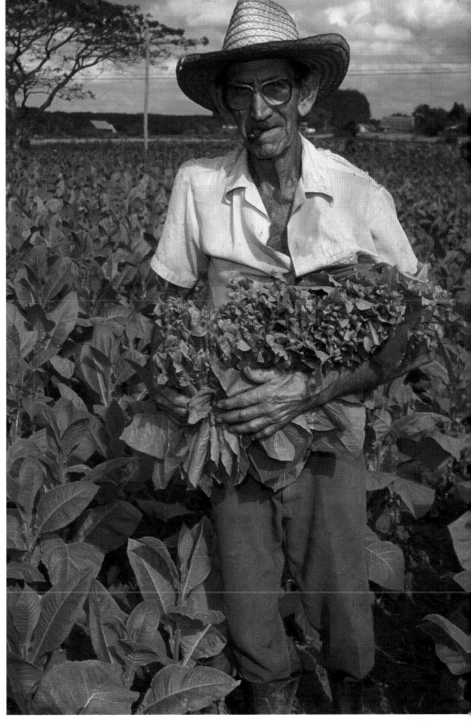

The lush valleys of Vinales produce some of the finest tobacco grown in the world. 25

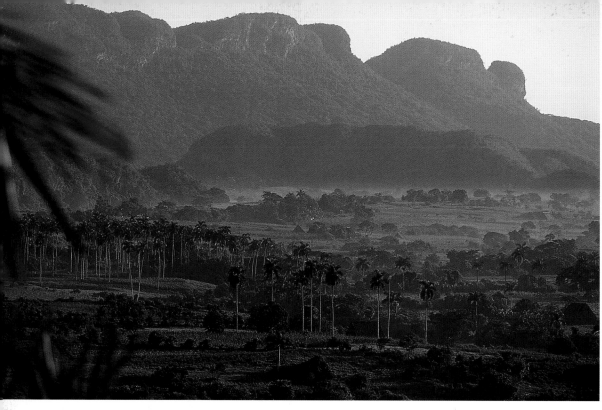

A game of dominoes is a pleasant diversion in the main square.

Early morning in Viñales valley, one of many in the Sierra de los Órganos, named by Spanish sailors who, seeing the hummocks from a distance, thought they looked like organ pipes. History fails to record what those sailors might have been drinking when they conjured up this image.

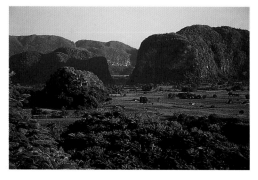

The mogotes of Viñales are riddled with cuevas, or caves, many of which remain unexplored. Other caves have been turned into cafés or museums, even a disco.

Life goes on much as it always has on the flat valley lands known as hoyos.

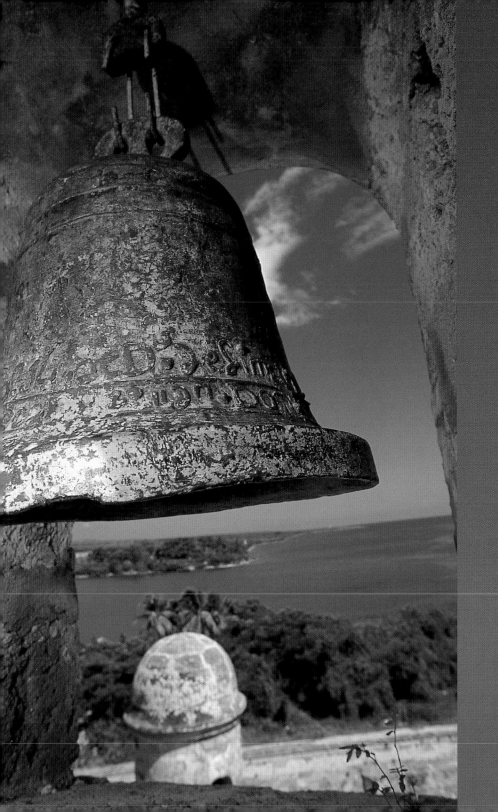

3

Cienfuegos

Pearl of the South

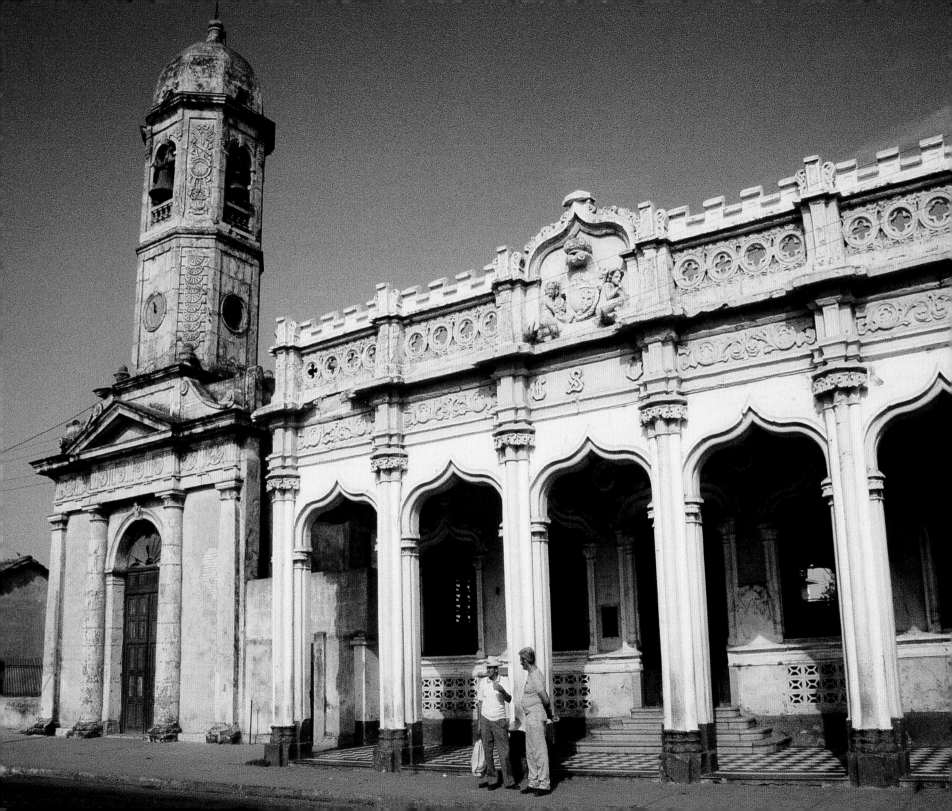

Facing page: The old Spanish casino in Palmires, 6 miles outside Cienfuegos.

Christopher Columbus discovered the lovely deep-water bay in the south central part of the island around which Cienfuegos nestles. The coast along here was favoured by pirates, which explains why there was a fort almost before there was a town. Castillo de Jagua was built at the mouth of Jagua Bay in the 1740s to protect the Spanish émigrés from Florida who arrived in the region. However, it was a Frenchman, Louis de Clouet, aided by fifty of his closest friends from Bordeaux in France and New Orleans, who, in 1819, founded what in 1829 became Cienfuegos (the town was named after a Cuban captain-general of the time). Today, with a population of 140,000, it's easy to see why this provincial capital, with its perfectly laid out streets (courtesy of the French), is often called the 'Pearl of the South' (and thus encourage you to forget that it's now the country's leading sugar port and an industrial centre, complete with abandoned nuclear plant, unfinished after the Russians left).

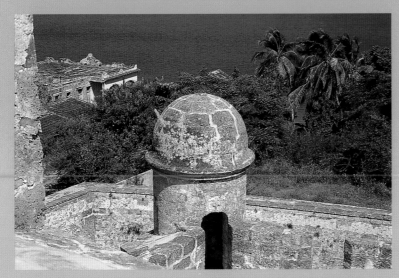

From the ramparts of the Castillo de Jagua, the Spanish protected the region from marauding pirates. Inside the fort, though, legend has it the defenders were terrorized by a mysterious woman in blue who wandered about at night.

It's also easy, on a sun-splashed morning visit to the still-impressive villas that line Punta Gorda peninsula, to understand why this colonial town was such a popular resort area in the 1950s. There is an impressively colonnaded Prado, a town square (complete with the usual statue of José Martí), a cathedral, a palace that used to be a casino but which is now a restaurant, and, most unusual, a marvellous theatre, Teatro Tomás Terry, built in 1889 by a wealthy sugar baron. The 850-seat theatre has fallen into disrepair but you can still see inside, and stand on the stage beneath delicately rendered frescoes where Enrico Caruso and Sarah Bernhardt once performed.

29

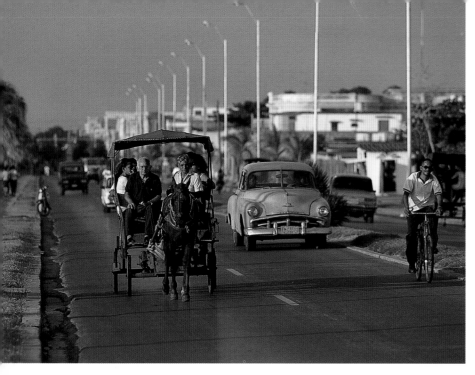

The rich used to sit on these porches along Punta Gorda. Now average Cubans get to do it.

Horse carts and vintage cars share space on the Malecón.

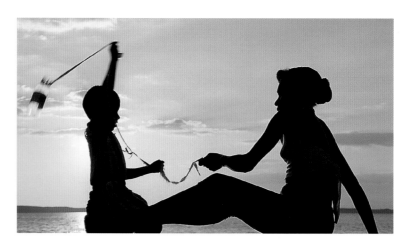

At dusk above Jagua Bay, one of the country's finest harbours, a mother plays with her son.

You don't see many street vendors in Cienfuegos. These two food vendors appeared particularly happy to be in business.

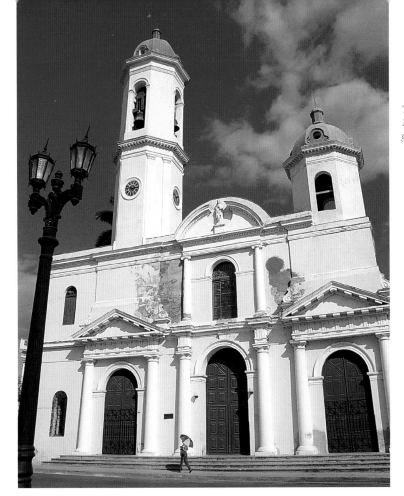

The Catedral de la Purísima Concepción was built between 1831 and 1869. The interior glows in spectacular fashion thanks to the stained glass windows depicting the twelve apostles.

Cooling off in Jagua Bay.

The French bequeathed to Cienfuegos lovely straight streets, perfect for bike riding on a hot afternoon.

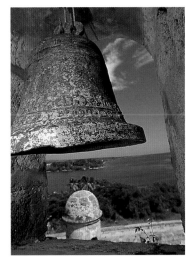

A bell in the Castillo de Jagua, strategically located at the entrance to the bay.

31

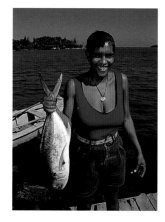

A young woman and the sea.

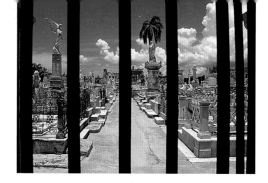

Necropólis Tomás Acea.

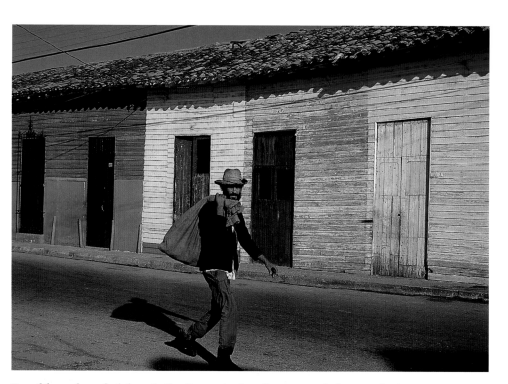

One of the many old wooden residences that still line Punta Gorda.

One of the workers who help make the city a centre for coffee, sugar and tobacco production.

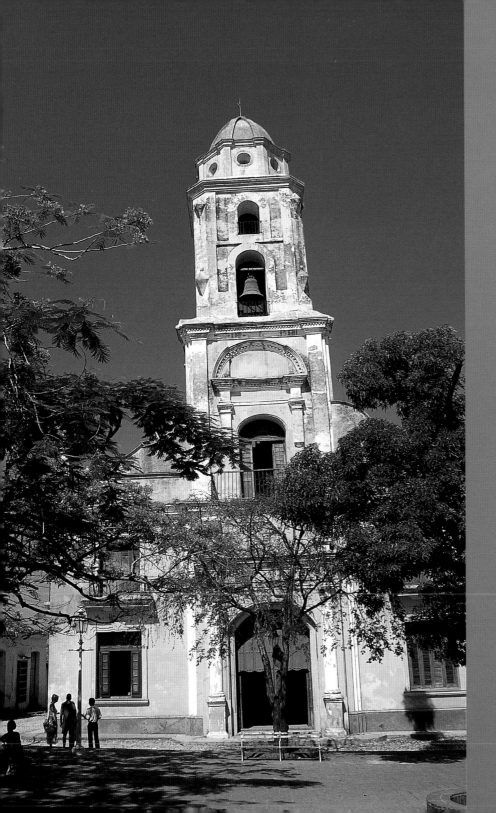

Cuba

Portrait of an Island

4
Trinidad

cobblestone plazas where time stands still

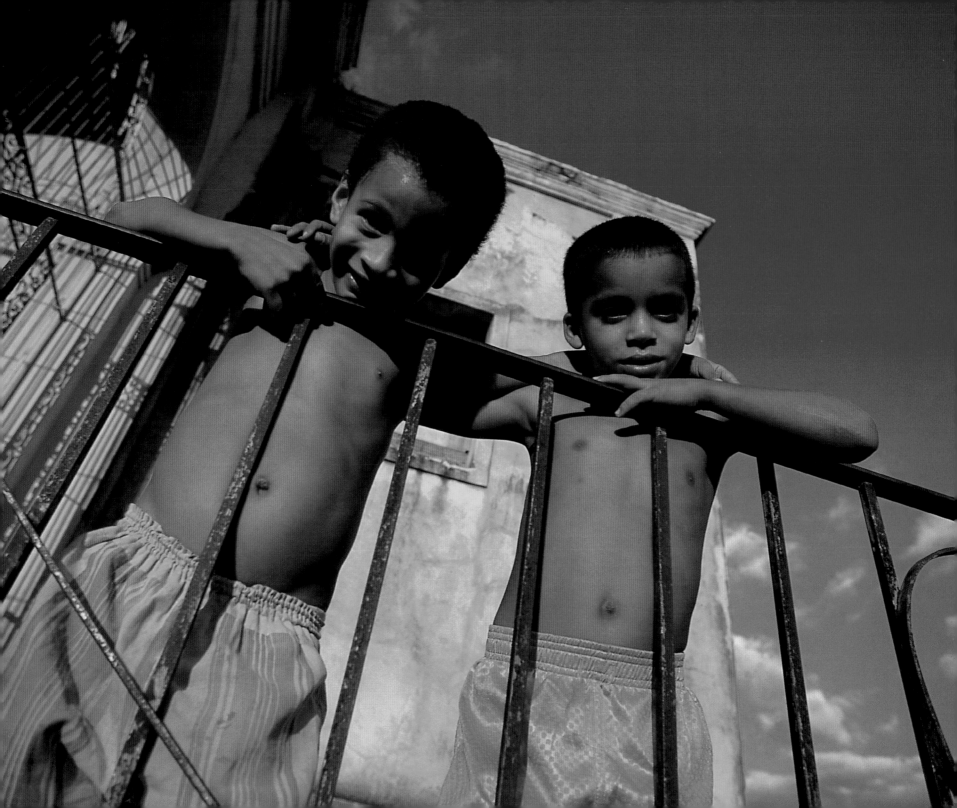

Facing page: *The old colonial section in the north end of Trinidad where these two children pause on a hot afternoon.*

Trinidad is often called the most colonial of Cuban cities. It has been cut off from the rest of the island since its founding in 1514 by Spanish explorer Diego Velázquez thanks to a potent combination of geography (sandwiched between sea and mountains), and suspicion (prior to the Revolution, Havana believed it a hotbed of revolutionary discontent; after the Revolution, Havana still believed it a hotbed of revolutionary discontent).

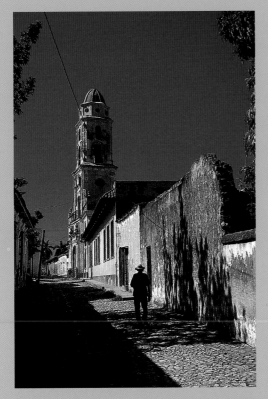

Previously a convent, the Church of San Francisco de Asís is located on Calle Echerrí. Today, the structure is neither a church nor a convent, but the intriguingly named Museum of the Battle Against Bandits (Museo de la Lucha Contra Bandidos).

The ruin of the Iglesia de Santa Ana. It looks older, but the church was remodelled as late as 1800, and the bell tower wasn't added until 1812.

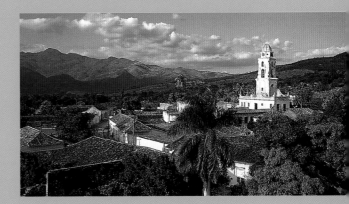

Those are the Sierra del Escambray Mountains in the background. They have helped keep Trinidad removed from the rest of the island for centuries.

Originally, the town relied on the pirates passing through who brought slaves and discovered gold in the nearby mountains. That all changed when the gold ran out, and Trinidad concentrated on sugar. By the end of the eighteenth century there were 56 sugar mills in the area and more than 12,000 slaves. Any doubts about why they used to call sugar 'white gold' disappear as soon as the visitor arrives. The town is full of eye-catching mansions and palaces built by the sugar barons at the height of their prosperity during the nineteenth-century boom years. Alas, the boom, as all booms do, came to an end, helped along by slave revolts, the European development of the sugar beet, and competition

35

A little boy pauses along Calle Hernández in the centre of town.

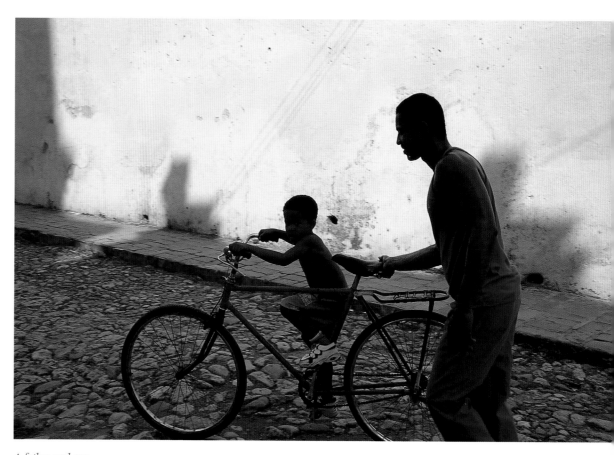

A father and son.

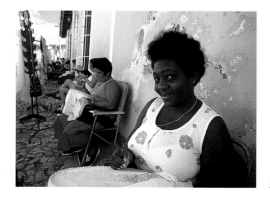

Elaborate knitting is a famed local handicraft.

36

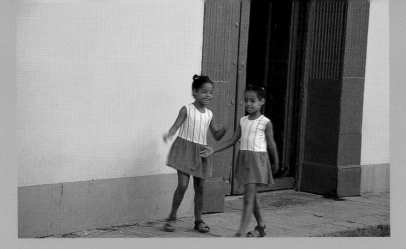

Two shy sisters on their way to school.

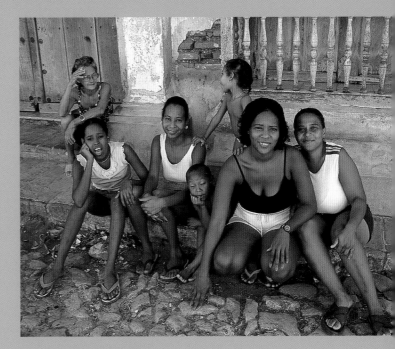

Street kids near the Plaza Mayor.

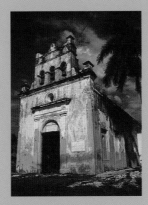

The ruin of a church in the nearby town of Casilda.

from nearby Cienfuegos. Still, the beauty of Trinidad remains, caught in shades of pink and blue and ochre. That beauty is particularly evident in the area abutting the Parque Martí (named after guess who?) The cathedral, Iglesia Parroquial de la Santísima Trinidad, built between 1817 and 1892, off the Parque Martí, has the distinction of being the largest church in Cuba. The Plaza Mayor, also in the town centre, is one of the most beautiful squares in the country with its gardens enclosed by white wrought-iron fences.

A detail of the ornamental fencing in the Plaza Mayor at the centre of town.

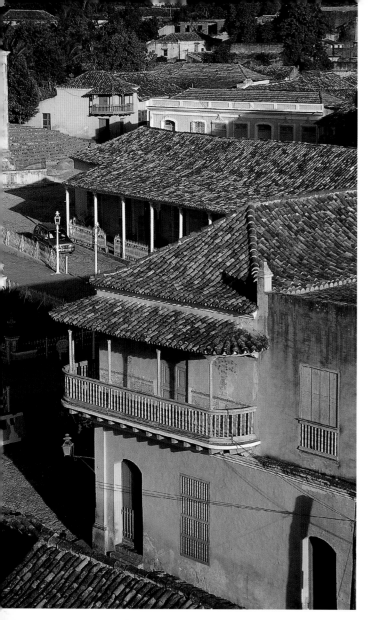

During the sugar boom, many of Cuba's most spectacular mansions were built around the Plaza Mayor.

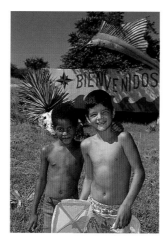

Bienvenidos!

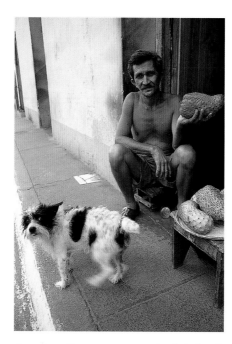

A vendor selling soursop, a popular fruit found throughout the West Indies.

Facing page: *Valle de los Ingenios, the Valley of the Sugar Mills. In the 19th century during the sugar boom, numerous sugar mills dotted the valleys of Santa Rosa, San Luis and Meyer. Twelve thousand slaves once toiled in these mills.*

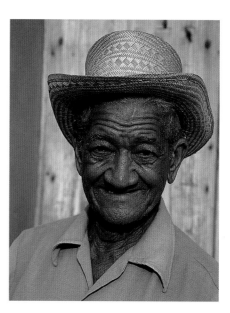

A sugar cane worker in town for the afternoon reminds us that, although tourism now fuels the area's economy, sugar production remains important.

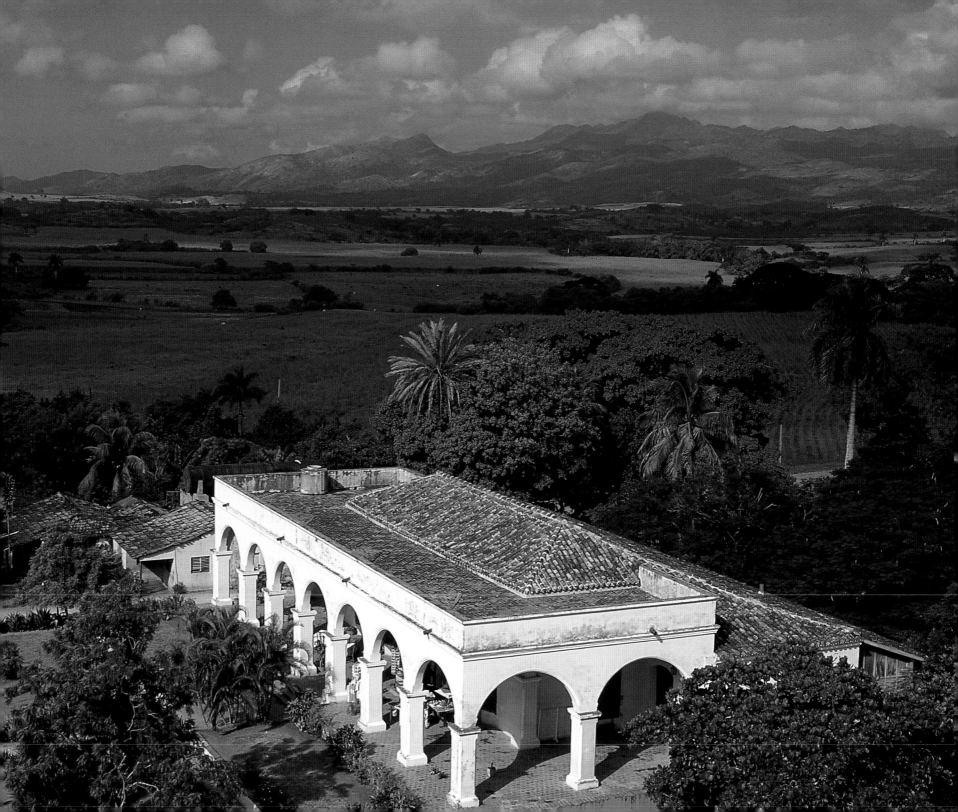

A family on its way to the weekly market.

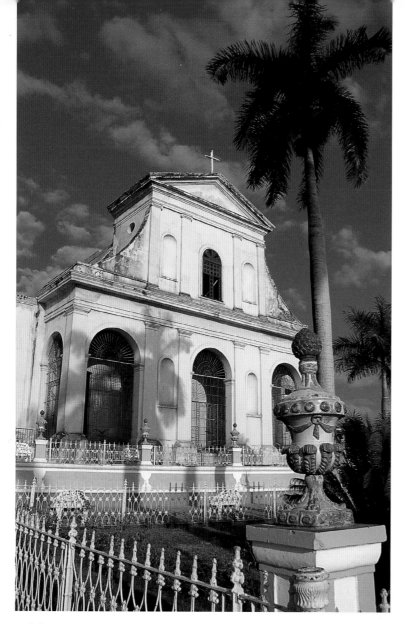

Built between 1817 and 1892, the Iglesia Parroquial de Santísima Trinidad advertises itself as the largest church in Cuba.

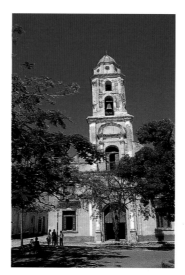

Trinidad's beauty is not restricted to its architecture.

The bell tower of San Francisco de Asís, completed in 1813. Its bell was added in 1853, made by a Frenchman, and weighing over two tons.

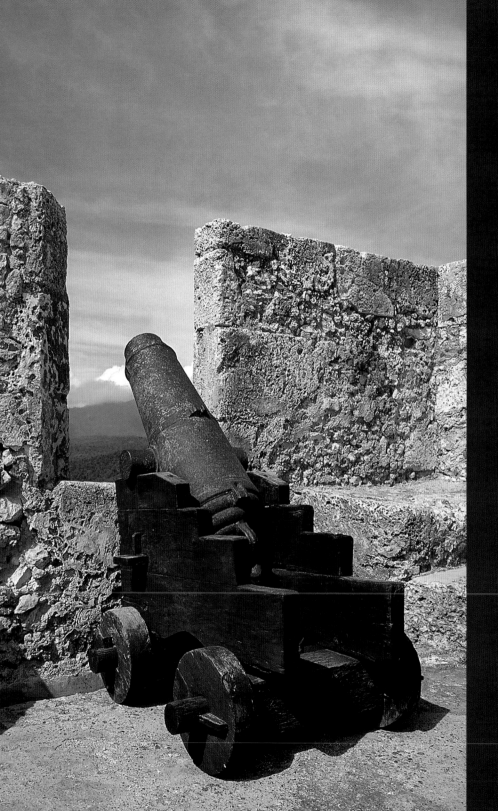

Cuba
Portrait of an Island

5

Santiago de Cuba

the Revolution's first city

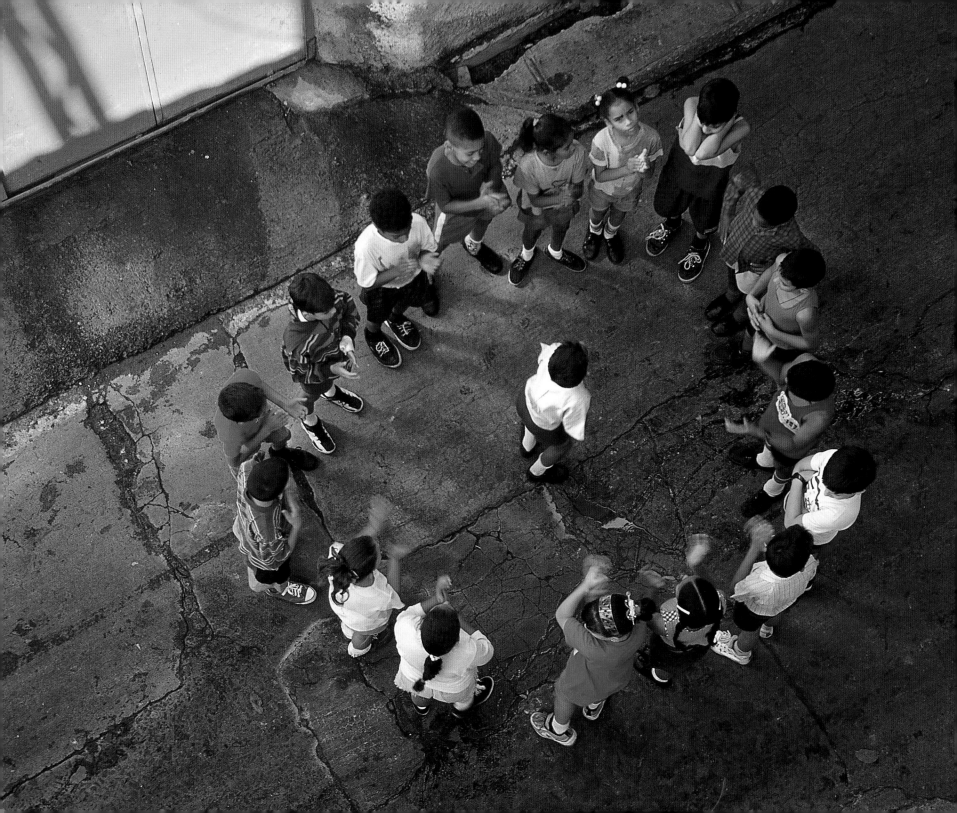

Facing page: *School children playing a game on a side street.*

If you want to change the course of Cuban history, better start in Santiago. Cuba's second largest city (population 400,000), built on rolling hills overlooking a bay, is nicknamed 'the Heroic City', and it's little wonder. When Carlos Manuel de Céspedes, Cuba's Abe Lincoln, freed his slaves and called for the independence that set off a revolutionary war in 1868, he did it in Santiago. When Cuba's war for independence required one last futile gasp in 1879, that gasp came from Santiago. Nine years later, the U.S. declared war on Spain and destroyed the Spanish fleet stationed in the bay at Santiago. The charge up San Juan Hill occurred just outside Santiago. When the Spanish finally surrendered and left Cuba for good, they did so at Santiago (the Cubans were not allowed into the city to attend the ceremonies).

Workers in Old Town on their way home.

The Casa de la Trova, home to son, the famous Cuban folk music popularized by the Buena Vista Social Club. Cuban musicians still flock to the club from early in the morning until late at night.

The fight to remove the dictator Machado from power in 1933 began in Santiago. When the young Fidel Castro decided to raid a military barracks to launch his fight against the Batista regime in 1953, he chose the Moncada Barracks at Santiago. Later, Castro and his brother Raul escaped Batista's troops and hid out in the nearby Sierra Maestra mountains. When the Batista regime finally fell, Fidel insisted on liberating Santiago first, before moving on to Havana.

43

Today, Céspedes, who more or less started it all, is hailed as the father of the nation, and the main square in the city has been named after him. Of course, there is a statue in his memory. What's more, José Martí, another great hero of the independence movement, is buried in a local cemetery, Santa Ifigenia.

Like other cities along the south coast, Santiago was founded around 1514 (it was the island's capital until 1553), and fortified in 1662 after years of being subjected to pirate attacks (the fortifications did not prevent the English from sacking the town and destroying it in 1662). Earthquakes have repeatedly levelled the city over the years, while the Spanish ruthlessly killed off most of the area's original inhabitants. They then imported thousands of slaves from Haiti and Africa who were needed to work the nearby mines and sugar cane fields. French settlers fleeing the slave revolts in Haiti began arriving in droves after 1791. Today, Santiago retains a reputation as the most Afro of Cuban cities, enlivened with a continuing French influence, and reputedly the island's friendliest citizens. It isn't just history that's made here. The first musical group formed at Santiago in 1580. Both the *son* and *bolero* musical forms are said to have originated here. Santiago is also the hometown of Compay Segundo, the guitarist regarded as the patriarch of *son*. Segundo gained international fame when he appeared on the Grammy-winning Buena Vista Social Club album. Nowadays, everyone in the city appears to be a musician of some sort. There is music, and therefore life, everywhere, so it shouldn't come as a surprise that Santiago's annual carnival is regarded as the best on the island. Not history, exactly, but certainly Santiago's other speciality – a good time.

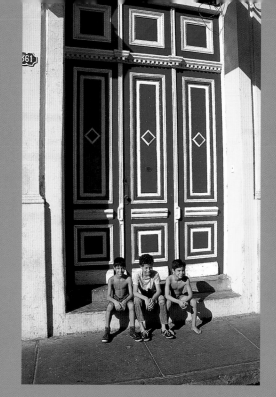

A majestic doorway looms over a trio of friends.

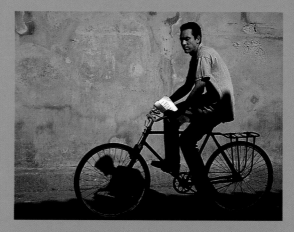

You see more bicycles than cars around Santiago.

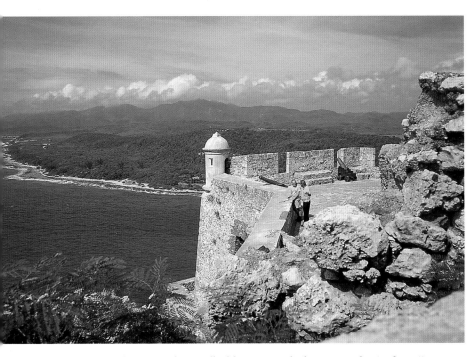

Dating from 1637, the Castillo del Morro was built to protect the city from pirate attacks. Of course the pirates, led by the infamous Henry Morgan, soon attacked and blew it up. The structure seen today was finished in the 18th century.

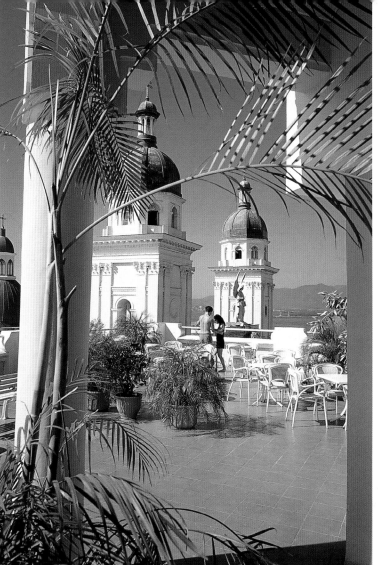

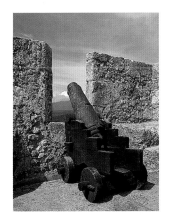

The battlements and a cannon at the Castillo del Morro.

A couple dances spontaneously on the rooftop patio of the Hotel Casa Granda, which overlooks the Catedral de Nuestra Señora de la Asunción. Since its construction in 1522, the church has been burned down, looted, and shaken by earthquakes. Each time it was rebuilt, bigger and better than before. Its current façade was finished in 1922.

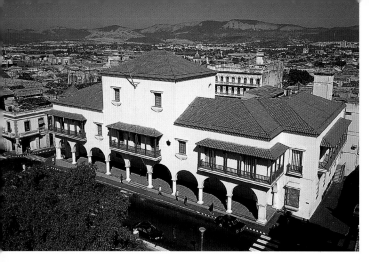

The town hall faces Parque Céspedes. Fidel Castro gave his first speech in celebration of the victory of the Revolution on January 1, 1959 from the central balcony here.

The Casa de Diego Velázquez, thought to be the oldest house in Cuba, was constructed between 1516 and 1530.

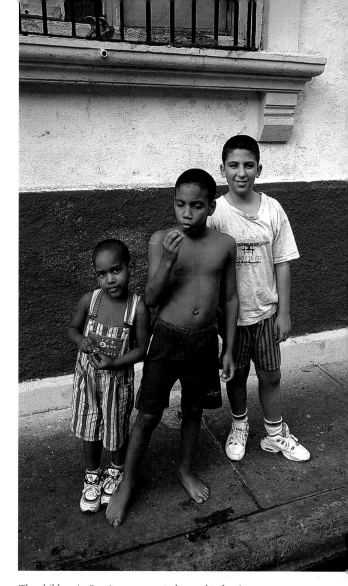

The children in Santiago appear to be used to having their picture taken.

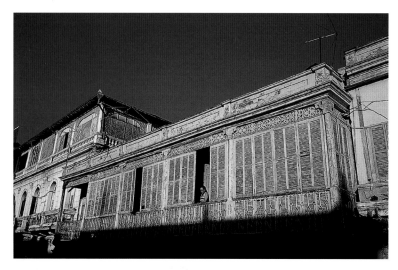

The wooden façade of an old house across from the Catedral de Nuestra Señora de la Asunción.

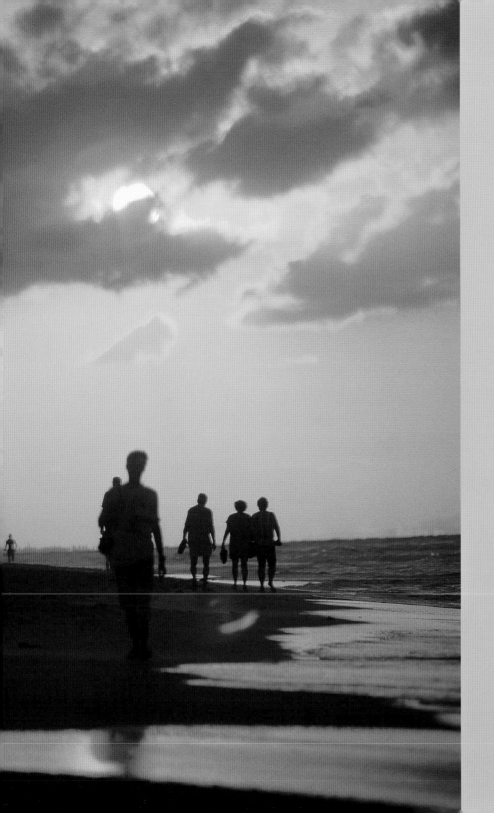

Cuba
Portrait of an Island

6
Beaches

between azure seas and sky

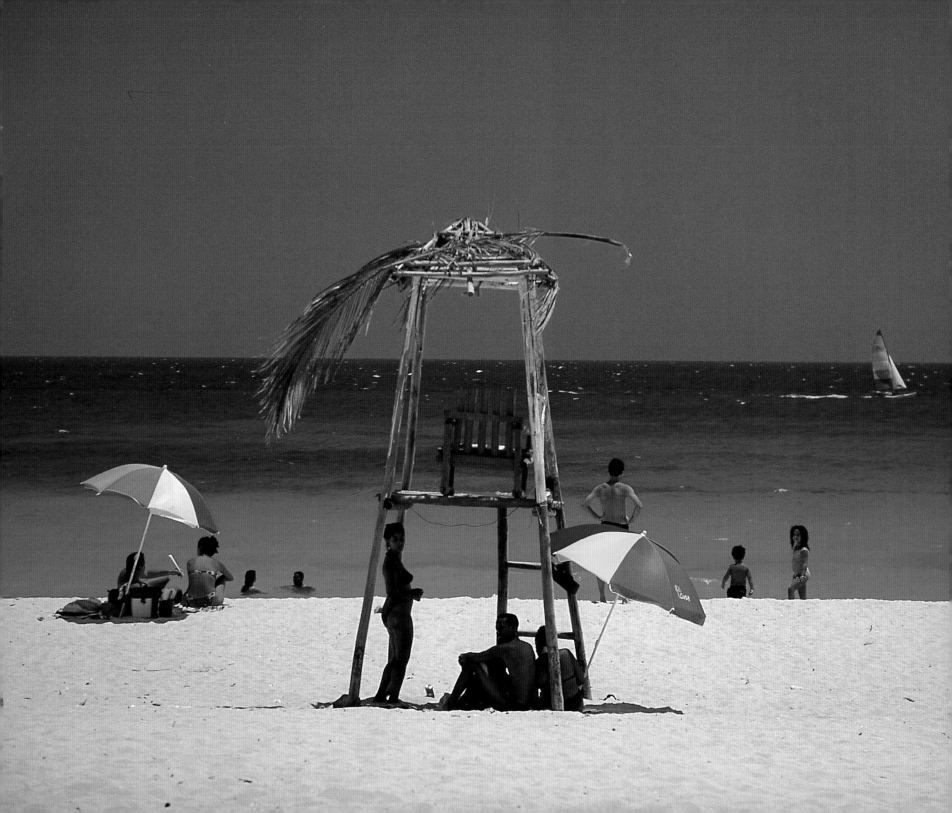

Facing page: Santa María del Mar, one of the beaches found in the Playas del Este, 11 miles east of Havana.

A vendor on the Varadero beach.

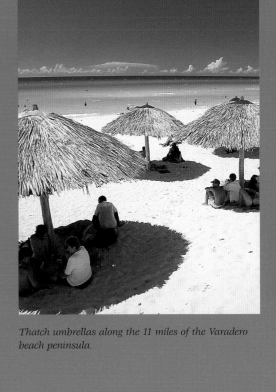

Thatch umbrellas along the 11 miles of the Varadero beach peninsula.

The beaches, not surprisingly, are Cuba's greatest tourist attraction. They are white and clean and, best of all, uncrowded even at the height of the tourist season. Tides are light, the strong undercurrents that plague Florida beaches are largely unknown here, and spectacular reefs remain helpfully just below the surface.

For most visitors, the beaches along the Hicacos Peninsula, an eleven-mile sand bar popularly known as Varadero (the name of the town at the west end of the peninsula), are the destination of choice. The wealthy of nearby Cárdenas first discovered Varadero late in the eighteenth century and began building get-away villas. The rich of Havana, 87 miles to the west, soon followed. However, it was the arrival in the late 1920s of the American billionaire Irénée Dupont de Nemours, who built a large estate she called Xanadu, that brought Varadero its greatest popularity. In the 1930s, even the American gangster Al Capone holidayed there. For a time after the Revolution, the peninsula was given over to visiting socialists and Cubans rewarded for their good works. Now, however, Varadero advertises itself as the largest resort in the Caribbean (the Dupont estate is a golf club) and the only Cubans one meets are employees. Thus the peninsula now gives off a slightly unreal quality, and you are left feeling that you are not really in Cuba (which, in a way, you're not).

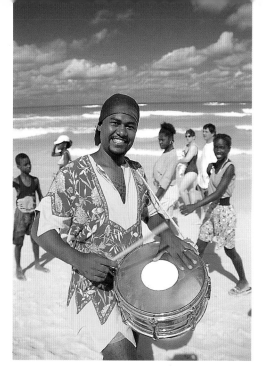

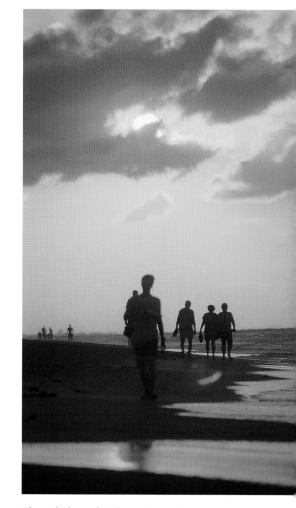

For a time after the Revolution, Varadero was a socialist resort for Cubans whom the government wished to reward. Nowadays, it's a major tourist destination and thus a magnet for colourfully dressed vendors and musicians.

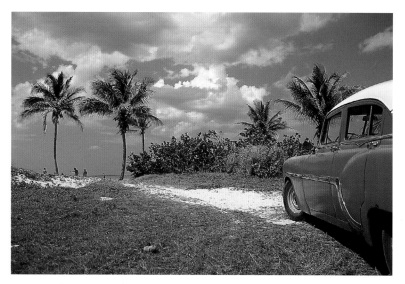

The end of a perfect day at Guanabo, one of the four beaches that make up the Playas del Este near Havana.

Car on beach at Guanabo.

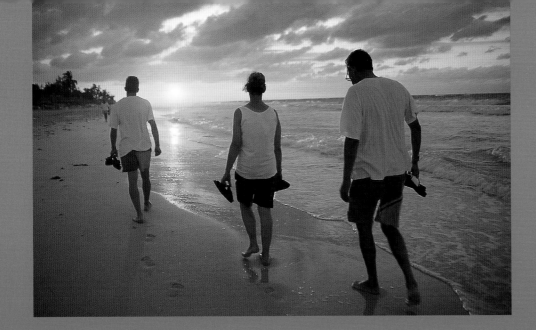

It's not hard to understand why Varadero is considered one of the most beautiful beaches in the Caribbean.

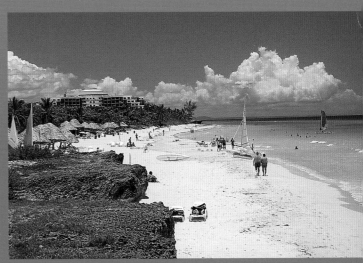

There are lesser-known beaches, at least to outsiders, which allow the visitor to feel part of real life in Cuba. On weekends, the four beaches that form the Playas del Este fill up with locals who make the fifteen-minute drive from downtown Havana, and are quite similar to the beaches at Varadero. Also further east along the north coast is the island of Cayo Coco. Most of its 143 square miles has been designated as a nature reserve, but it contains 14 miles of beaches that have become a major tourist attraction.

The spectacular Cayo Jutias beach outside Viñales is hidden at the end of a long tidal swamp road. The Ancón, just five miles from Trinidad, is perhaps the best beach on the south coast. Just about as impressive and much more remote, also on the south coast, is the barrier island of Cayo Largo, part of the 673 cays that form the Archipiélago de los Canarreos. Playa Girón is notable as the site of the so-called Bay of Pigs invasion in 1961 when 1,300 Cuban exiles came ashore and were quickly captured by Fidel's army. Cuba's most infamous beach is also its most inaccessible. Guantánamo Bay lies 43 miles east of Santiago de Cuba, but because of the U.S. naval installation there (since 1903), you can't approach.

However, you can travel across cactus-covered hills to a former military outpost called Mirador Malone, now a restaurant. There, you rent old Soviet-issue binoculars so that you can get a look at the U.S. base – it appears to have been conceived out of the movie fantasy of a small middle-American town. It's a perfect beach outing for those tired of the sun and up for a little harmless spying.

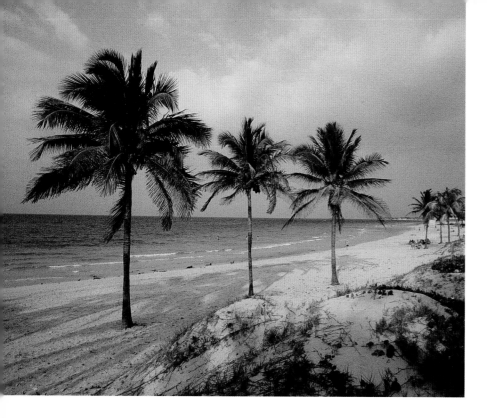

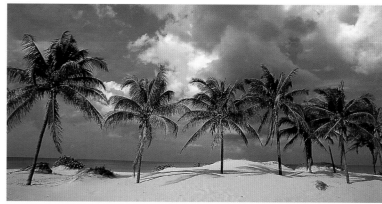

Sand dunes and palm trees line the Guanabo beach.

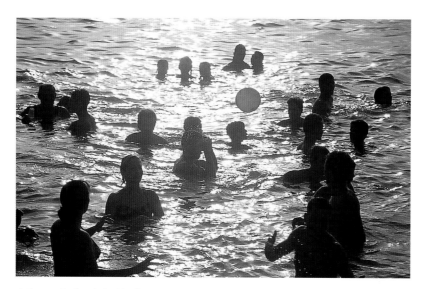

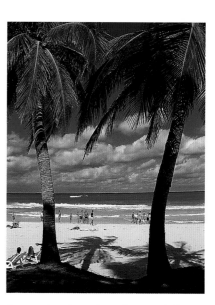

Sun, sand and swaying palm trees in front of the International Hotel on Varadero.

A day at the beach in Cienfuegos.

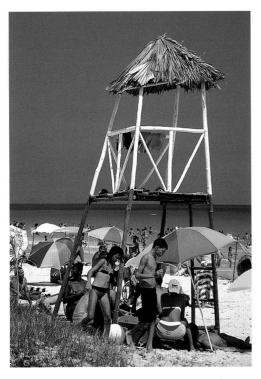

A busy weekend in July on the beach in Guanabo.

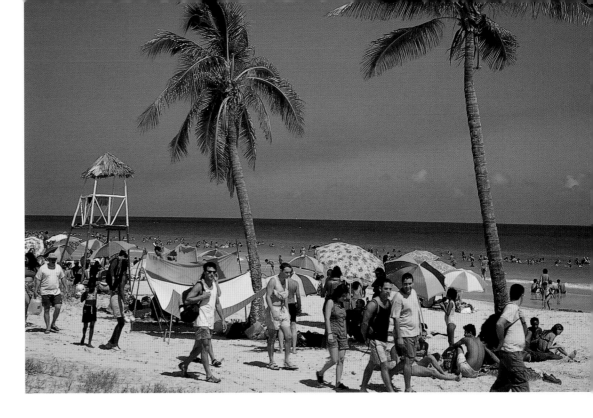

At the height of the winter tourist season, the beaches
fill with tourists from all over the world.

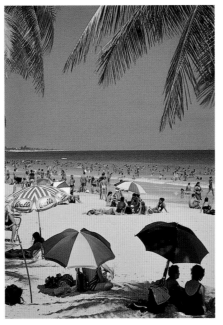

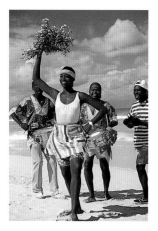

*Roaming troubadours
scour the beach on
Varadero looking for tips.*

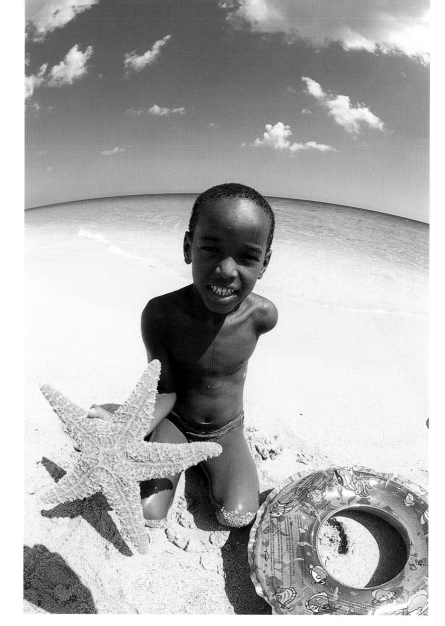

A little prince of the beach at Santa María del Mar.

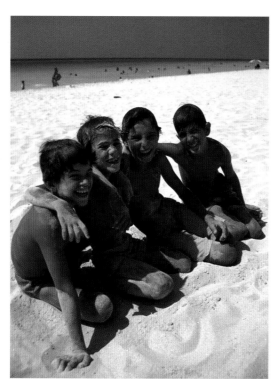

Playing in the sand.

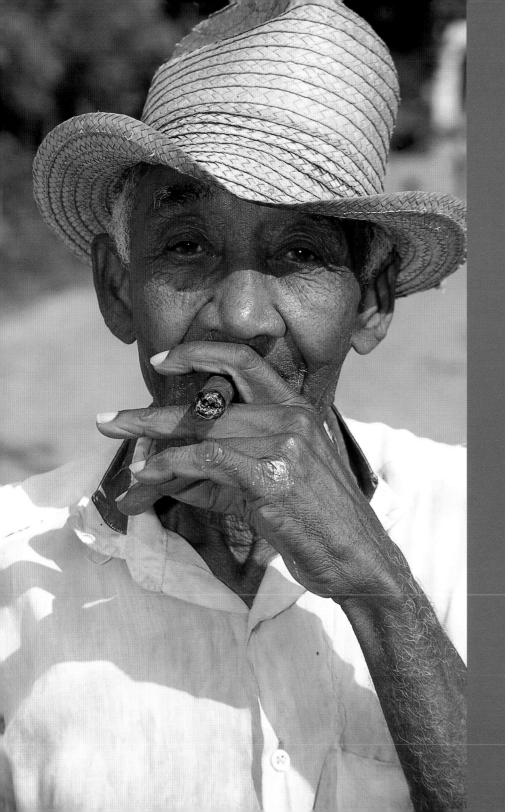

Cuba
Portrait of an Island

7

Tobacco
and Cigars

following the smoke trail

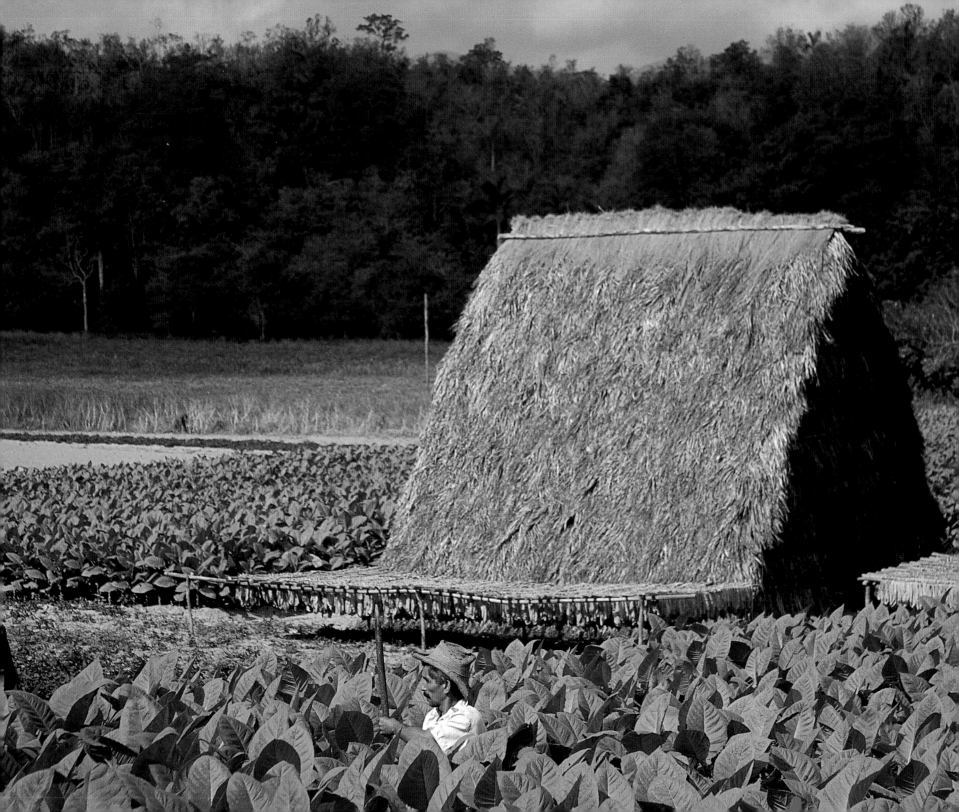

Facing page: *Picking tobacco in January.*

Legend titillates with the notion that Cuban cigars are rolled on a virgin's thighs. The casual visitor to Corona, one of the top five cigar factories in Havana, can't readily identify any virgins, certainly not virgins rolling cigars against their thighs. However, that's not to say the manufacture of cigars doesn't still approach that level of care. In fact, a good cigar roller, or *torcedor*, is more highly regarded than a doctor – at least, he earns more. Ironically, then, tobacco still provides a better-than-average living to the otherwise often exploited Cuban worker, just as it did early in the eighteenth century at the height of the slave era, when the big estates with many slaves discovered they could not produce the same quality tobacco as a small farm operated by peasants. Thus tobacco growing became the best-paying job around.

Just about everyone in Cuba these days has a cigar or two for sale.

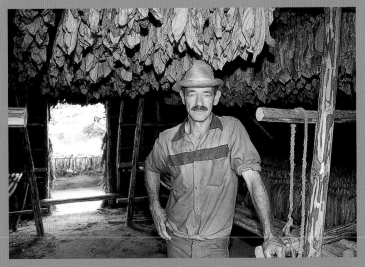

Tobacco drying in a casa del tobacco. *These tobacco barns face west and are covered in palm leaves. The tobacco leaves are hung in twos. The leaves take about 50 days to dry and turn from green to a golden brown.*

Four centuries later, there is still no such thing as automation in the Cuban cigar industry. At the Corona cigar factory in Havana, the product continues to be hand rolled by the 250 workers who toil there in rows (the most productive are seated near the front) beneath the *de rigueur* photo of Che (with a cigar, naturally). They are watched over by a lector who keeps them enthusiastic – and entertained with readings from poems and novels, as well as articles from the daily newspaper, *La Granma*.

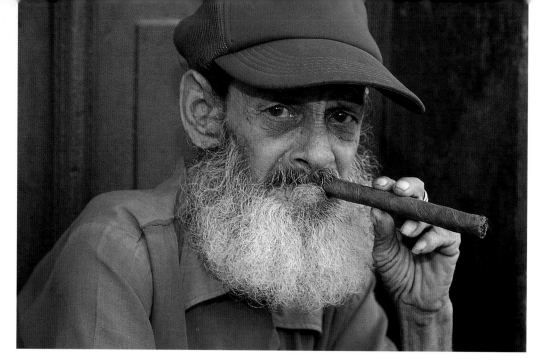

Any doubts that elderly Cuban men with interesting faces smoke cigars should be assuaged by these photos.

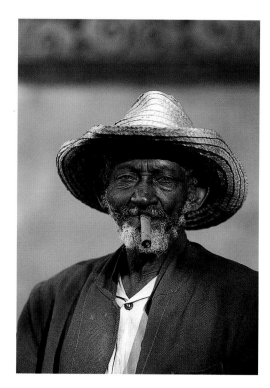

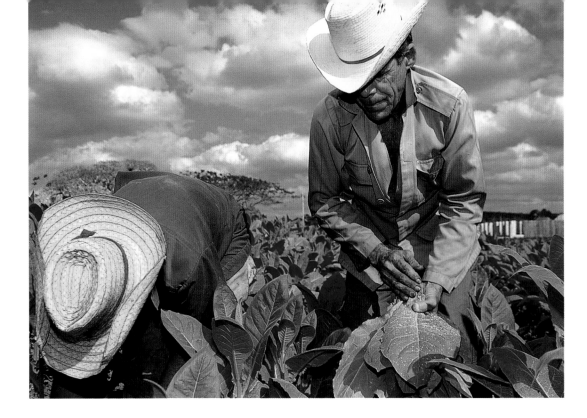

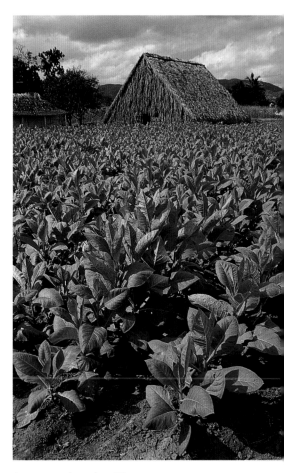

Harvesting tobacco plants in Viñales. The harvest lasts from January to March. The lower leaves are taken from the plant first, using a machete. Two weeks later the next layer of leaves is harvested, and a couple of weeks after that, the next row until the plant's highest leaf (the corona*), is cut.*

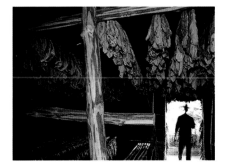

After a month of drying, the moisture still in the leaves causes fermentation that reduces the resin and nicotine content and gives the leaves a uniform colour.

A vega, or plantation. The vegueros, or planters, work their crops from October to January. The leaves reach their ideal height in about 45 days.

59

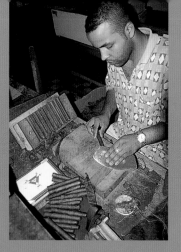

A torcedor in the 'galera', the workshop of the cigar factory.

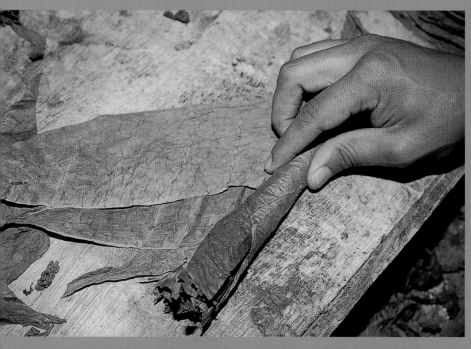

Rolling the criollo, *or filler leaves, into the wrapper.*

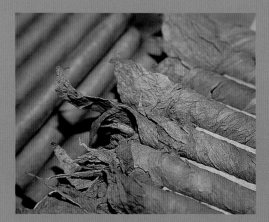

Cigars about to be cut to size. An adjustable guillotine-like device is used to trim them.

A true Havana cigar is created via a highly complex and secretive process that relies on the expertise of the tobacco master assigned to each factory. It is his talent for getting the blend, or *ligada*, just right, coupled with the ability of the roller (who can do up to 120 cigars a day), that is largely responsible for the quality of the finished product.

First, the roller lays out the filler leaves (which hold the cigar together and provide flavour and an even burn) combining *ligero* (strength), *seco* (aroma) and *volado* (burn). All this is accomplished according to a secret formula worked out by the tobacco master. The filler leaves, or *criollo*, are rolled in the binder, and once that is done, the cigar is cut to size with the use of an adjustable guillotine.

Such is the power of the Cuban cigar that before John F. Kennedy banned them from the U.S. (a box is now said to be worth $700 on the U.S. black market), he apparently stored away 1,000 for his personal use. However, would-be cigar smokers take note: Fidel, formerly Cuba's number one poster boy for a good (Cuban) cigar (and for whom the Cohiba, Cuba's most famous cigar, was created), gave them up a few years ago – for health reasons.

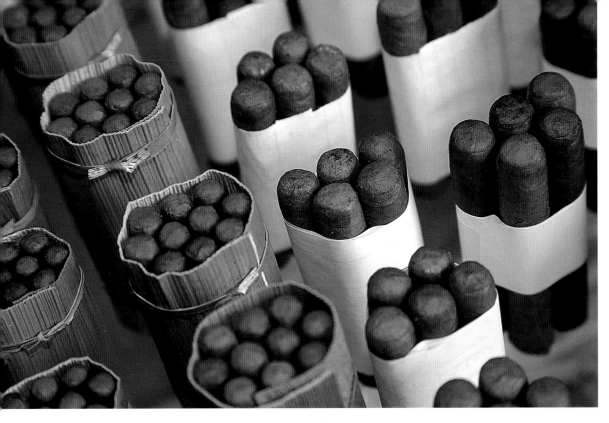

After the torcedores, or rollers, have completed their work, the finished cigars are checked for quality then laid in boxes, the darkest on the left, the lightest on the right, and stored in a cool room so that they won't lose their moisture before being shipped.

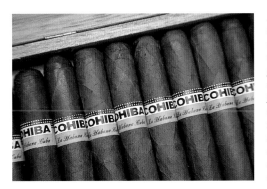

Fidel Castro himself is credited with the creation of the Cohiba, one of the most famous Cuban brands. Originally manufactured for his personal use, Fidel soon made them available to government officials and foreign dignitaries. The brand became available to the public in 1982, and today is regarded as Cuba's finest cigar. What marks the Cohiba from other cigars is its excellent construction and complex flavour, rich and full-bodied.

A good torcedor, or roller, can roll as many as 120 cigars a day. In the typical cigar factory, the torcedores work away in rows, the best of them seated at the front.

Heading home after a day's work. A productive worker in Cuba's tobacco industry earns more than many professionals.

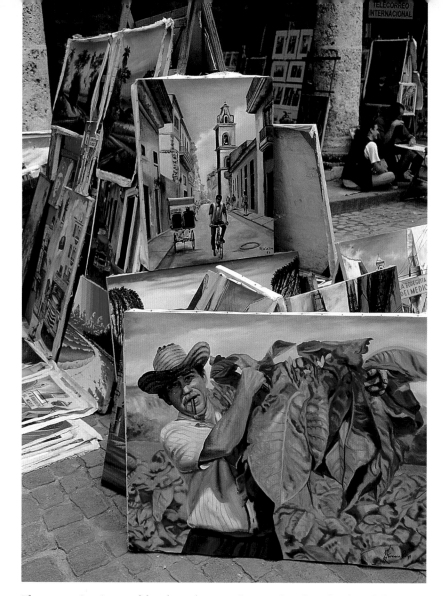

They even paint pictures of the tobacco harvest. These are for sale in the Plaza de la Catedral in Havana.

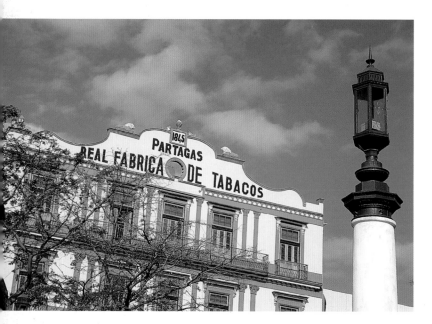

The neo-classical façade of the legendary Partagás cigar factory in Havana. They have been manufacturing cigars here for 158 years. Even the female receptionist puffs away on a good cigar in the afternoon, maybe because employees get to smoke free.

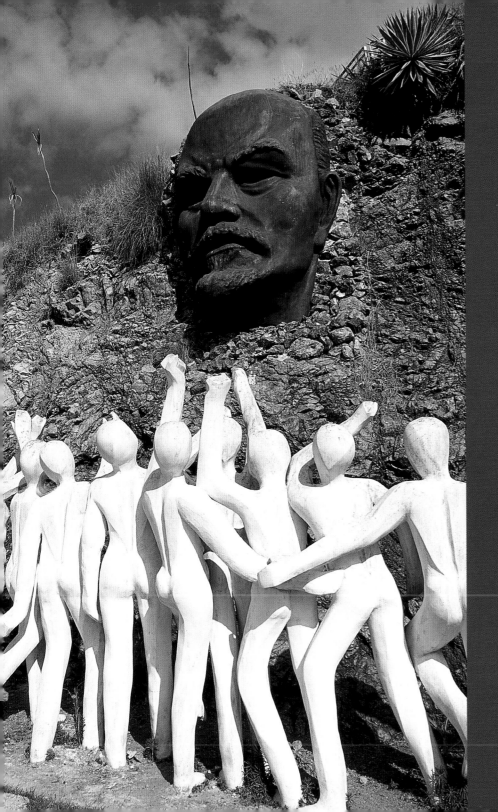

Cuba
Portrait of an Island

8
Politics

¡socialismo o muerte!

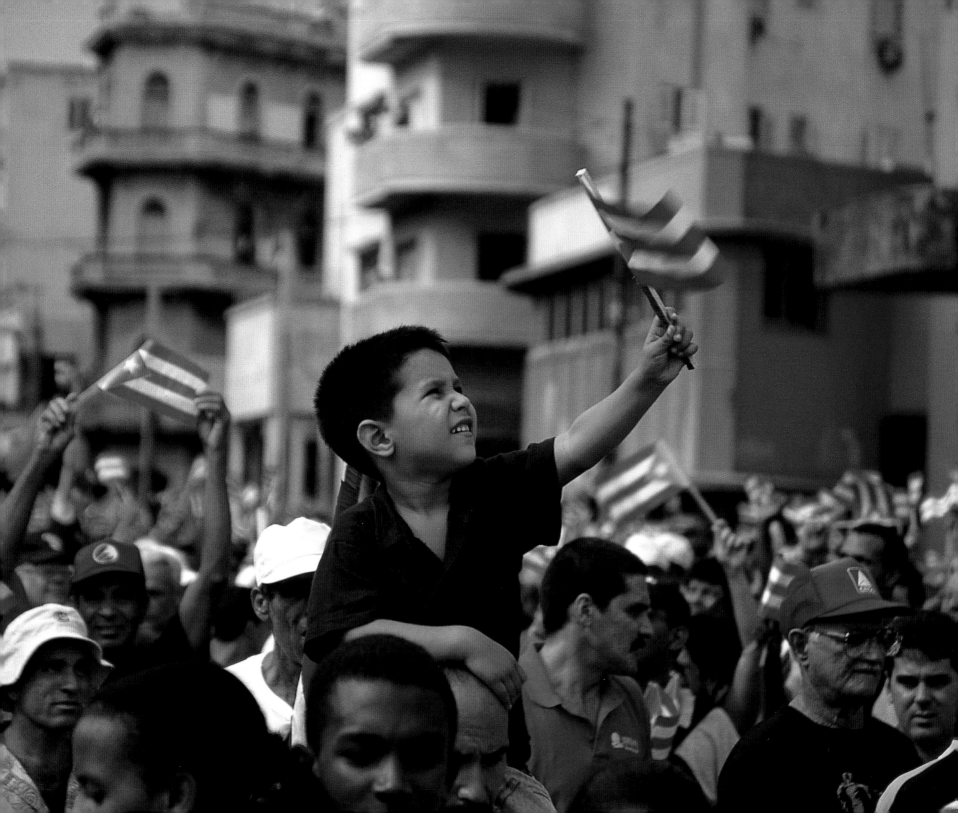

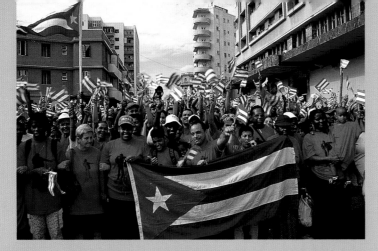

Facing page and above: A 26th of July demonstration against the U.S. embargo of Cuba. The state continues to mobilize hundreds of thousands of people for May Day Parades or anti-American demonstrations. Workers are given the day off to attend, and are transported by bus. Public transportation is shut down.

If Fidel is in the air of Cuba, Che is all over its billboards and T-shirts, not to mention the four-storey-high mural in Havana's Revolution Square. You can't go anywhere without seeing that iconographic photograph of Che Guevara taken by Alberto Diaz Gutiérrez (known as Korda after the Hungarian expatriate film-makers, Zoltan and Alexander Korda). Korda, who had become court photographer to the Revolution, took the shot of Che seen round the world in 1960 at a funeral for the victims of a steamboat sabotaged in Havana Bay. Titled *Guerrillero Heroico*, the photo captures a stern, angry visage, part movie star action hero, part people's warrior. It became a symbol of student radicalism during the 1960s, and it endures to this day. (Korda died in 2001, never having received any royalties for the picture.)

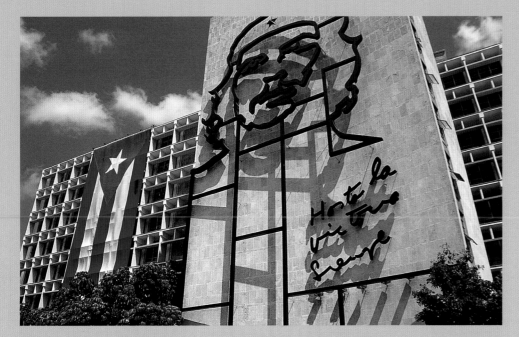

Ministry of the Interior building in the Plaza de la Revolución, Havana. The bronze image of Che (taken from the famous photograph by Korda) was erected in 1995.

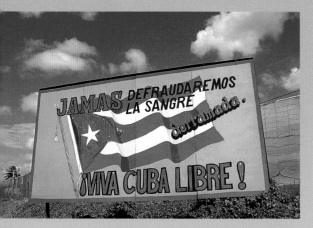

The billboard reads, 'We will never betray the blood that has been spilled.'

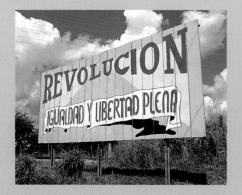

The Revolution is alive and well and living on billboards.

The second most famous face of the Cuban Revolution (next to Fidel, of course) was not Cuban at all. Ernesto 'Che' Guevara came from a bourgeois family in Rosario, the second largest city in Argentina (Che is actually the diminutive for 'you' in Spanish as in 'Hey, you.' It became so identified with Guevara that he took it as his 'official' middle name, with a lower case 'c'). His father, a non-practising Catholic, ran a *mate* farm at Alta Gracia, near Cordoba, and was active in left wing politics.

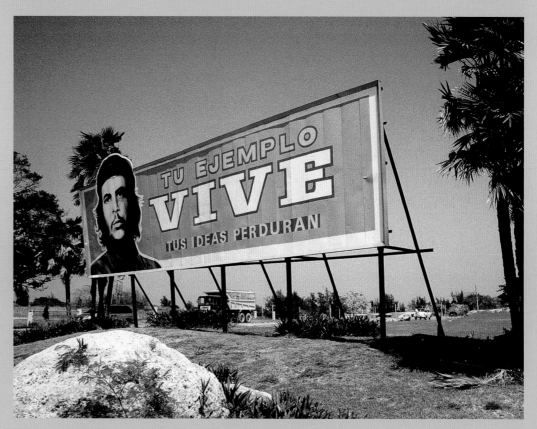

'Your ideas live on.'

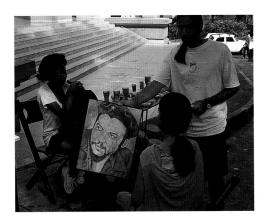

Che, everywhere!

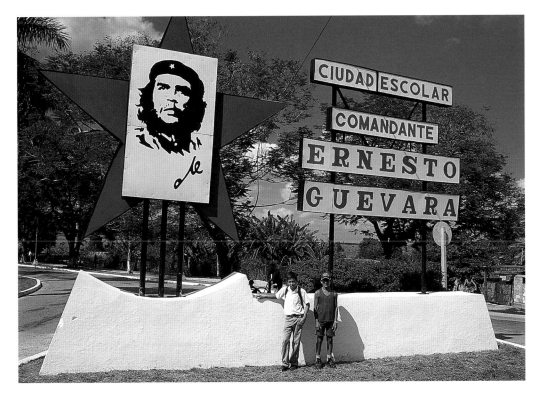

A Havana fixture, 'Wilkie' is a dance instructor, and man-about-town who appears to make a pretty good living getting his picture taken by visiting photographers and tourists.

'Trabajadores' or workers.

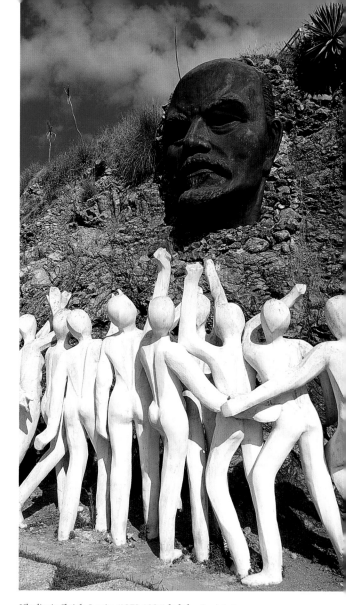

Vladimir Ilyich Lenin (1870-1934) led the Soviets to power after the Russian Revolution in October, 1917. Not even the Russians have much to say these days about him. But in Cuba he remains a presence, certainly in Parque Lenin Colina, outside Havana.

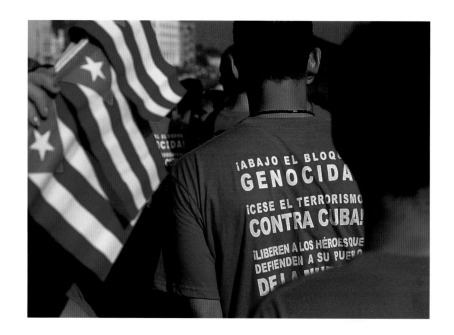

As a child, Che suffered from asthma, so spent much time away from school being educated by his mother and his four brothers and sisters. He entered university as an engineer before changing to medicine. As a student he travelled a good deal through South America on foot and on bicycle. His transformation into a revolutionary fighter began after he witnessed a CIA-financed right wing coup in Guatemala that forever turned him anti-American. He worked as a street photographer and as a doctor at the general hospital allergy ward in Mexico City. By 1955, he had read everything by Lenin and Marx (he could also recite Kipling's poem 'If'), had learned to hate the profit motive and believe fervently in the purging effect of revolution. Che and Castro met in Mexico City in 1955 and talked the night away. Che thought Castro possessed the characteristics of a great leader, a romantic adventurer willing to risk death for a noble cause. He enrolled in

After nearly 44 years in power, Fidel's name is still popular graffiti throughout Cuba.

Castro's army as a doctor and *guerrillero*. By the time he led rebel troops into Havana on December 31, 1959, Che had become one of the Revolution's most important figures, hugely popular with common people. After the Revolution, the man who hated money and capitalism briefly became the head of the Central Bank. More in keeping with his image, Che then tried to spread the Cuban revolution to the outside world, without great success. In Bolivia, the people never bought into his brand of revolution and he remained isolated and on the run before being killed in an army ambush in early October, 1967. The authorities, anxious to ensure that the world knew Che was dead, photographed his corpse, then amputated his hands, and made a wax mask of his face that was sent to Argentina. None of it worked. The cult of Che was born and nearly 40 years later, thanks in part to Korda's photograph, he continues to live on T-shirts and posters around the world. Every morning, Cuban schools resound with the sound of children singing, 'Pioneers of communism, we shall be like Che!'

A '57 Chevy stands in stark contrast to an anti-imperialist slogan.

Postcards sold throughout Cuba.

Facing page: 'The fatherland before anything,' announces this billboard.

The recipe for a powerful Cuban drink includes 'equality and full liberty.' Presumably you mix them together and shake.

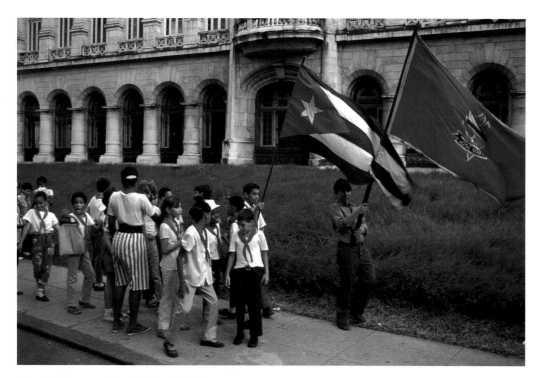

70 *School children parading with the Cuban flag.*

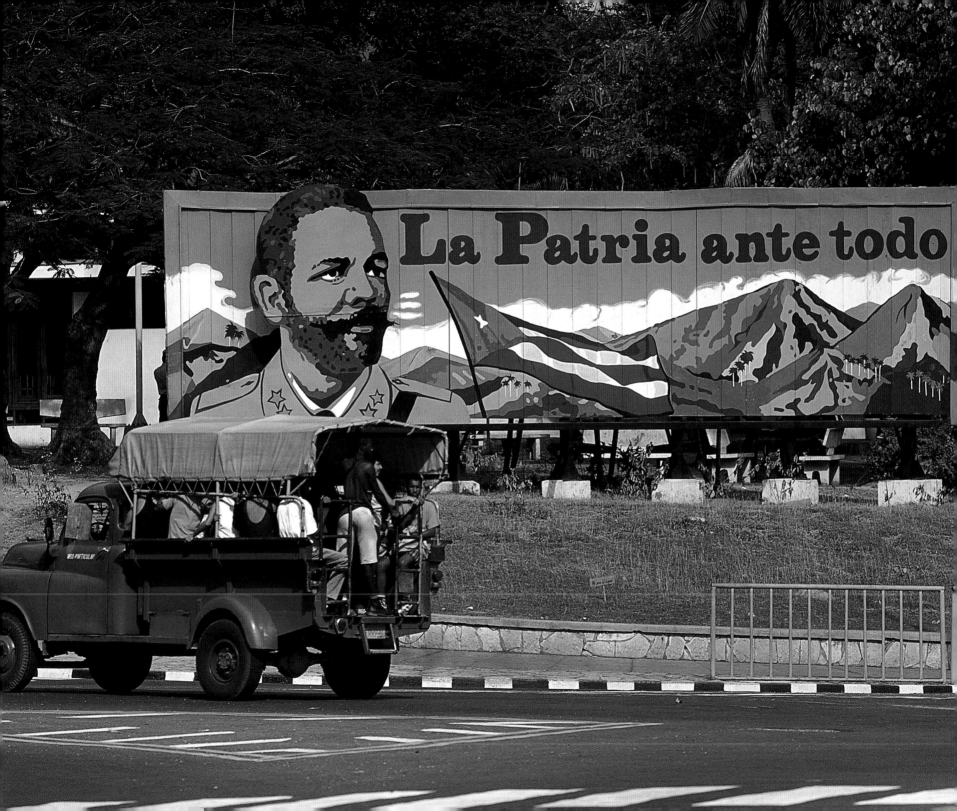

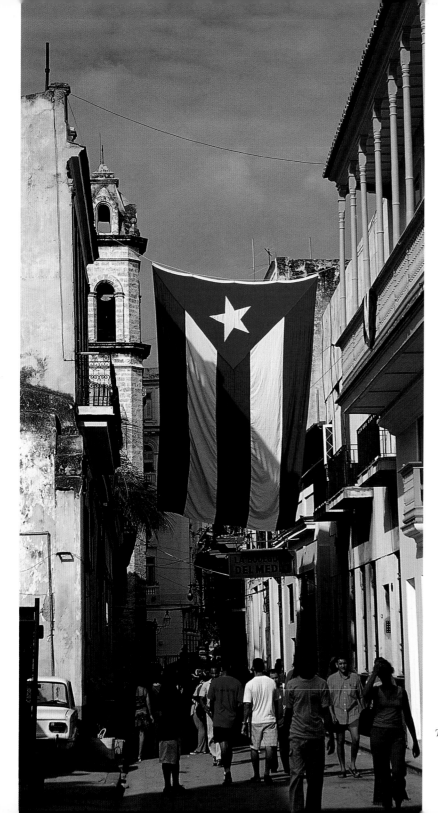

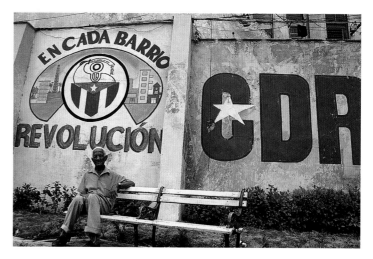

CDR - Committee for the Defence of the Revolution.

The Cuban flag towers over a street in Central Havana.

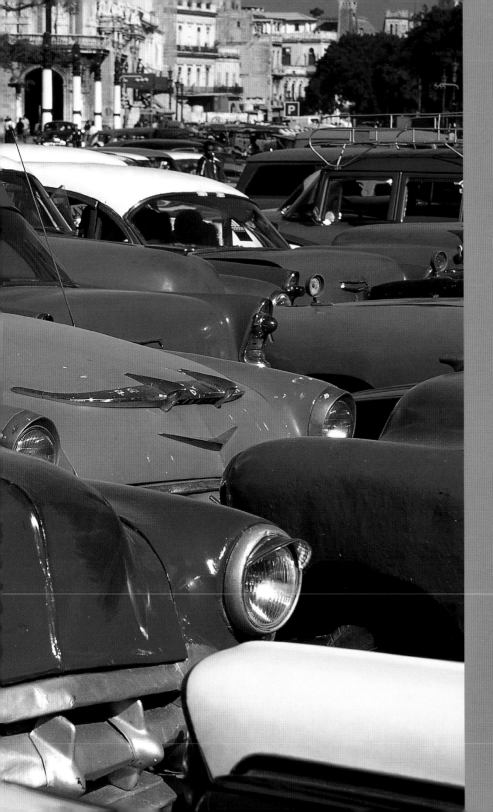

Cuba

Portrait of an Island

9

Vintage Autos

freewheeling history, made in the U.S.A.

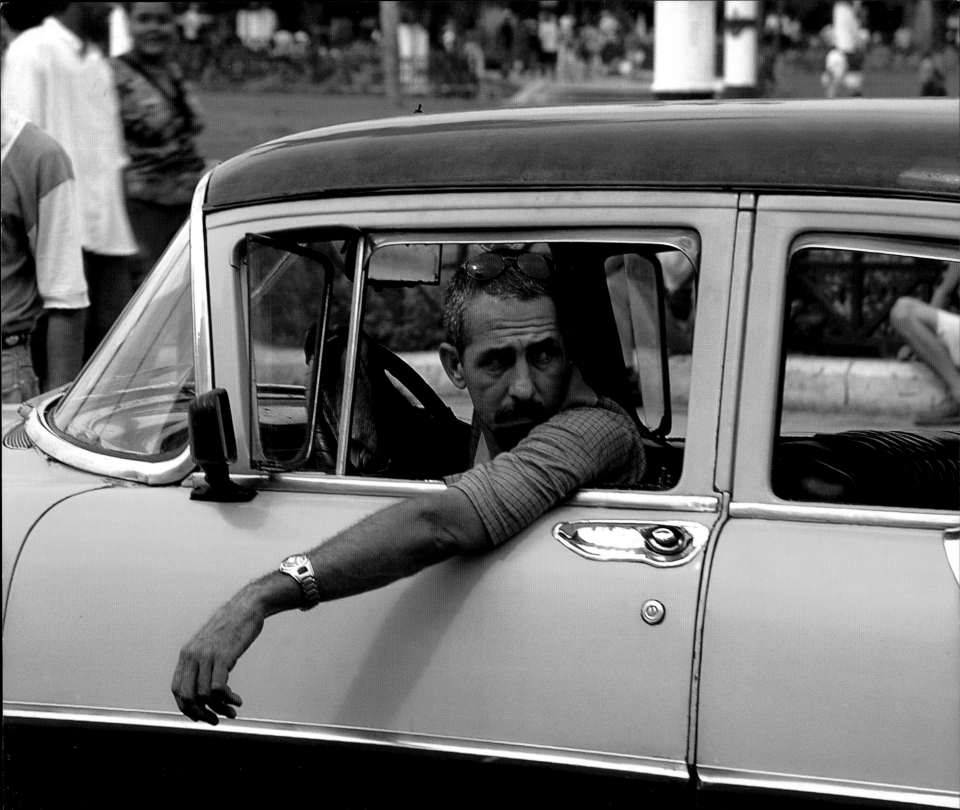

Facing page: *Making – what else in Cuba? – a left turn.*

The automobile helps define the continuing sense in Cuba that one is moving forward staring into a rear view mirror. These are not *just* cars on the Cuban streets, you understand, but *old* cars, vintage model Cadillacs, Fords, Chevrolets, Chryslers, and Buicks, kept in pristine condition by a combination of happenstance, history, and mind-boggling ingenuity.

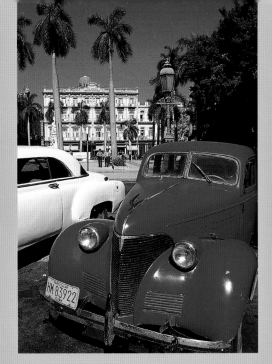

In the main square of Cienfuegos.

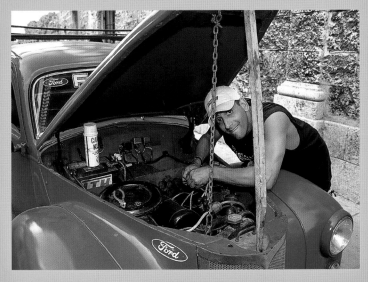

Evidence that just about everyone who owns a car in Cuba is turned into a mechanic whether he wants to be or not.

There are approximately 60,000 vintage automobiles on the island. About half are 1950s models. Amazingly, the other 50 per cent date from the 1930s and 1940s. It is said to be the largest collection of classic American cars outside the United States.

Most of these cars are more than 40 years old, and no longer simply a means of transportation; survival has transformed them into treasured heirlooms passed from generation to generation. Just about everyone you encounter is some sort of mechanic, full of inventive ideas about how to keep the cars running. Russian Volgas and Ladas are cannibalized for parts. A combination of oil, shampoo and soap forms a usable brake fluid. Bonnet ornaments are created from scratch. Sometimes necessity creates so much invention that no more than a door panel remains of the original car.

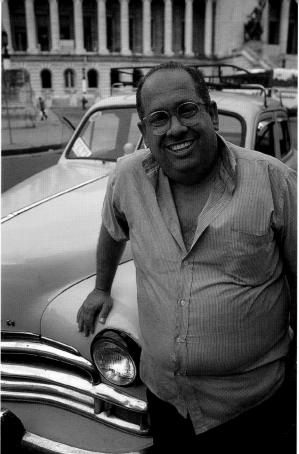

Proud owners.

Still, like much else in the country, the future casts its doubts, and the old cars are not free of them. It used to be that one out of every three cars on the streets was a vintage American auto of some kind. Now that number has fallen to about one in five, and increasingly there are more European and Japanese imports. Not surprising, then, is the international movement to promote the cars as a cultural treasure, like the gondolas of Venice. 'How these cars survive,' said a visiting car enthusiast, 'it's like, how did they build the pyramids?' A combination of oil, shampoo, and soap?

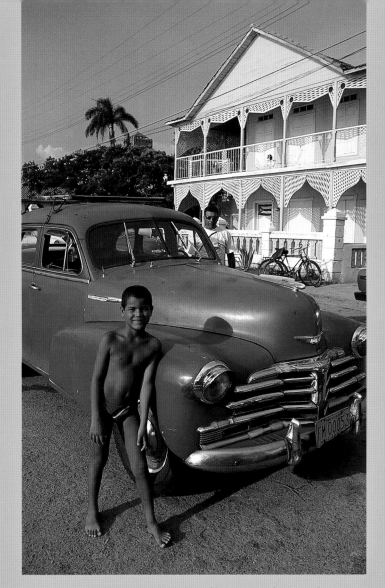

A small boy with a big car on the fashionable Punta Gorda in Cienfuegos.

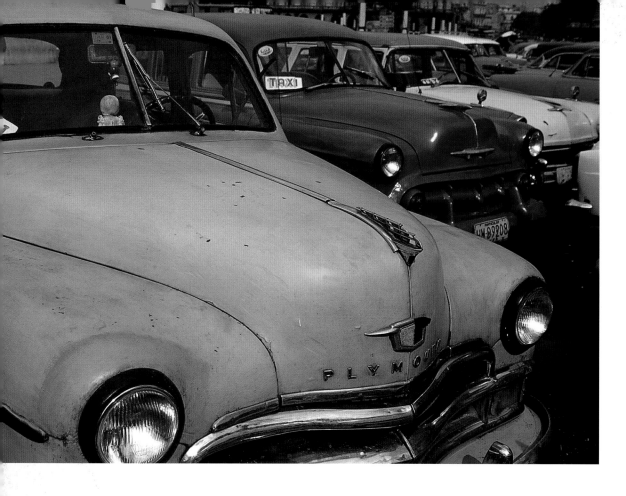

The best vintage-car-watching on the island can be found around the Capitolio building in Havana.

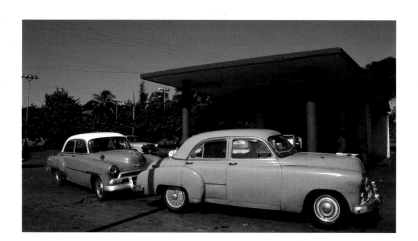

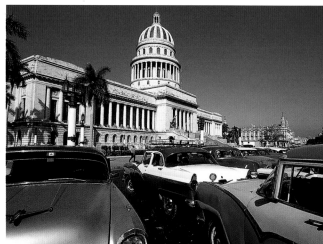

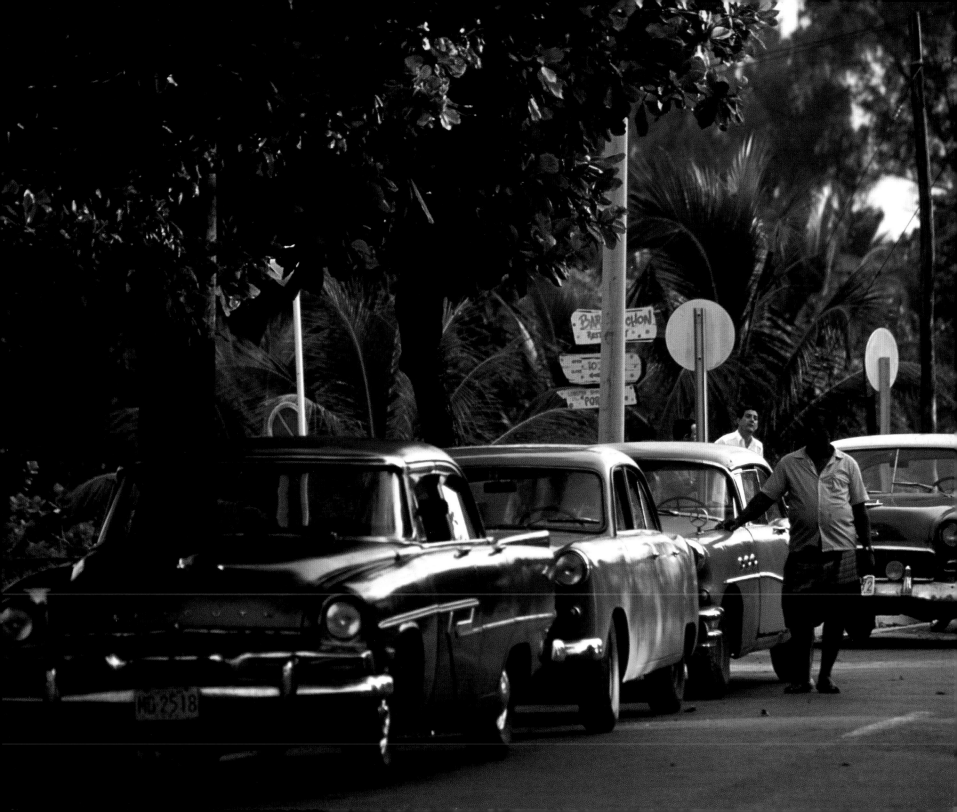

Bright red in the sun of Guanabo beach outside Havana.

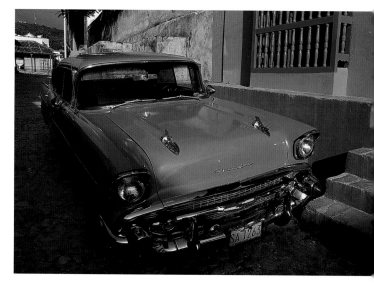

Parked in Trinidad.

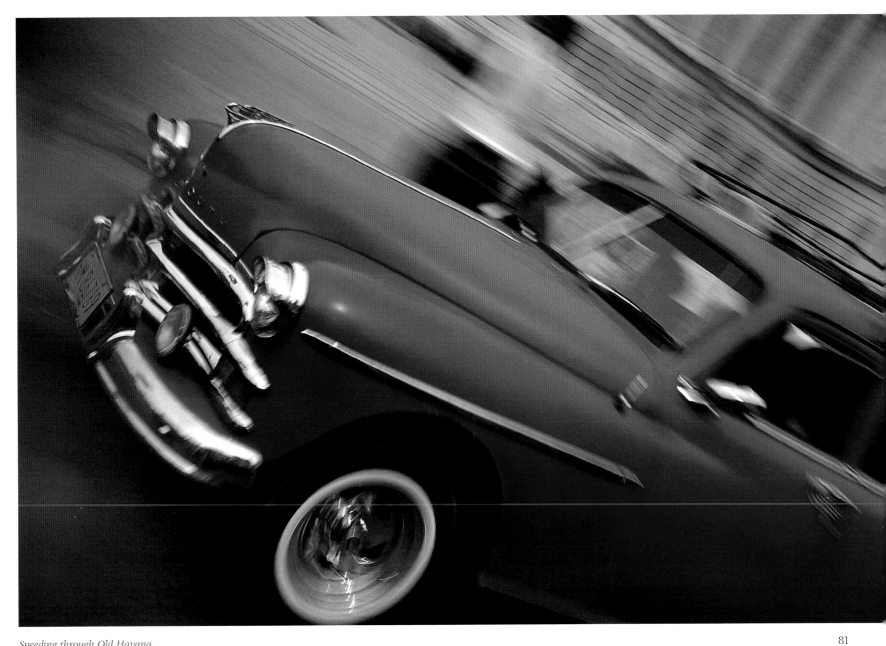

Speeding through Old Havana.

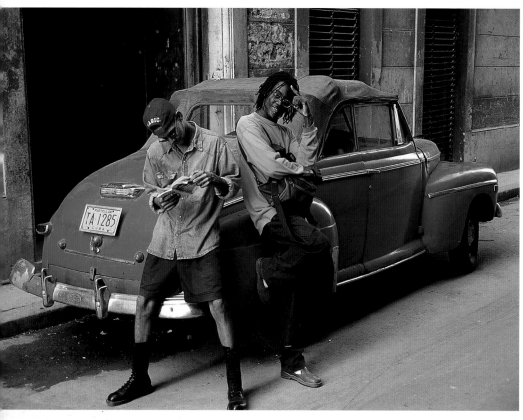

On a back street in Old Havana.

An American classic.

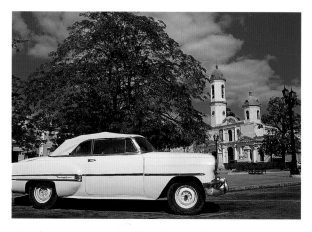

Near the Catedral de la Purísima Concepción in Cienfuegos.

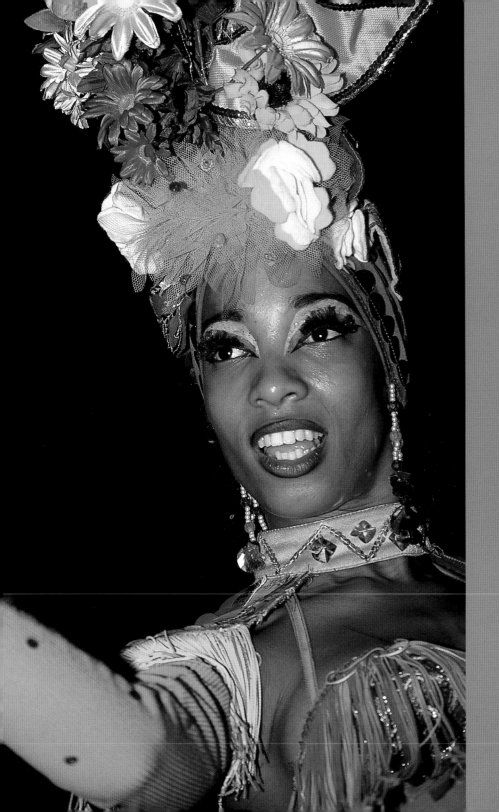

Cuba

Portrait of an Island

10

Cuban Rhythms

face the music and dance

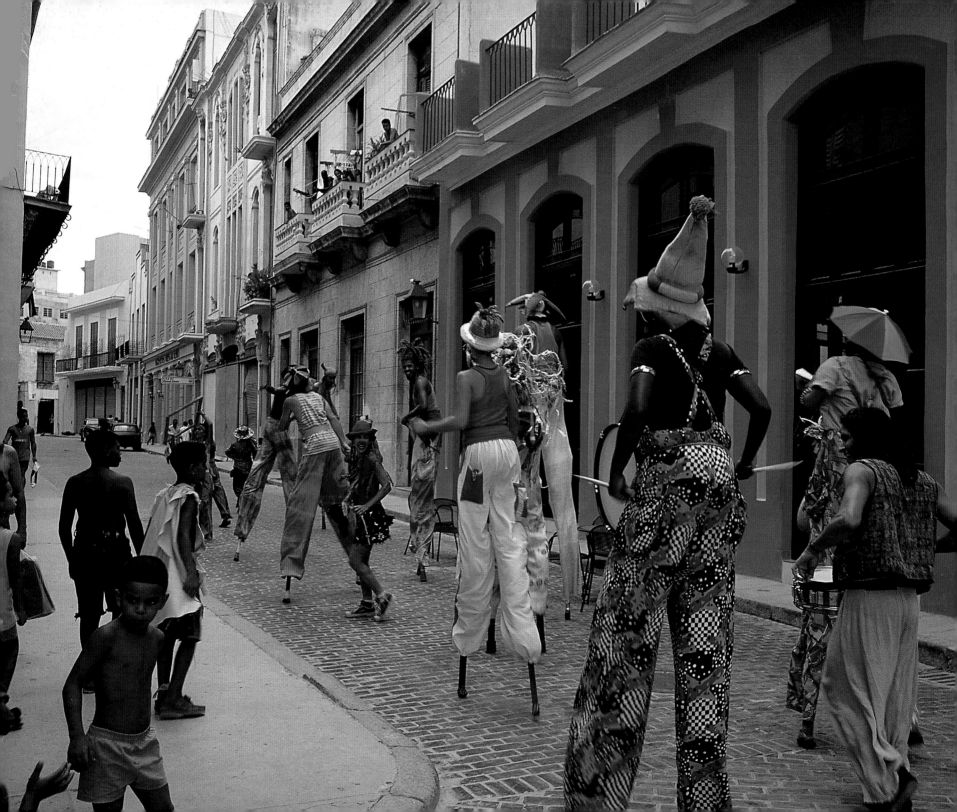

Music pours out of the Cuban soul like perspiration from skin. Musicians gather everywhere, on street corners, in parks, in doorways; someone picks at a guitar, plays a horn, bangs a drum. The state licenses 12,000 musicians who are said to play in 30 different genres. A constant and quite amazing musical soundtrack accompanies Cuban life. It's a soundtrack that now sweeps the world, inspiring books on the subject (*Dancing With Fidel* by Stephen Foehr), a flood of CDs, and an entire galaxy of recently discovered and aptly named Afro-Cuban All-Stars.

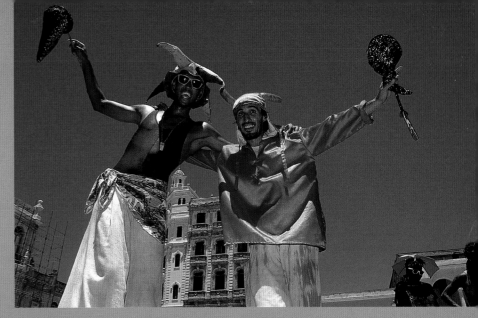

Carnival winding down one of Old Havana's side streets.

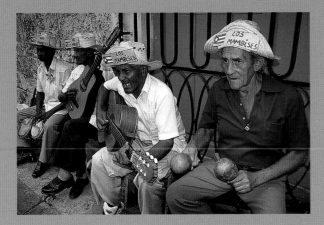

One of the many 'freelance' groups working tourist areas for tips.

Pause a moment to listen and you can hear the history. The slaves brought life and the drum to the music. The Spanish supplied not only melody but the guitar and violin. The richly romantic sound of the *danzón*, based on the French quadrille with a little Creole mixed in, was part of the dance music the Spanish evolved, as well as the *habanera* which was used in Bizet's *Carmen*.

Curiously, for a long time the guitar and the drum remained separate. It wasn't until the late eighteenth century they began to meld together in various musical forms that evolved into rumba, as well as a type of romantic ballad in the early 1900s known as the *trova*. There are good arguments to support the theory that Afro-Cuban music may have formed the basis for jazz. Black soldiers in town for the Spanish-American War heard the *danzón* orchestras that were all the rage and brought the music home with them to New Orleans where it was integrated into the Dixieland that evolved into jazz.

85

The 1920s saw the development of *son*, a form that came out of the dances performed by the sugar cane workers in Oriente province. *Son* remains a musical influence. One of its fathers, Compay Segundo, helped give it new life when he became part of the Buena Vista Social Club.

In the 1940s a faster version of *danzón* music became known as the mambo, and soon the mambo craze swept the world. That was followed by the Cuban-inspired cha-cha-chá.

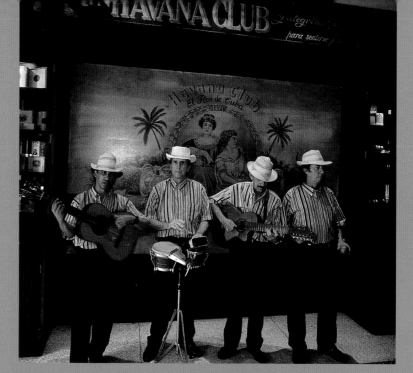

Troubadours in the Havana Café on Havana's waterfront.

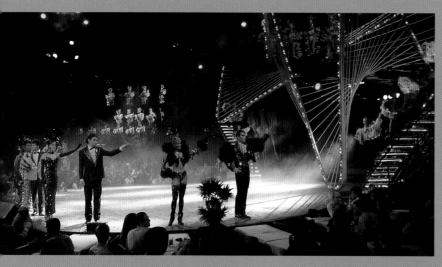

In the 1950s the Tropicana was known as 'the most beautiful nightclub in the world'. In those days the club seated 1,750 amidst a lush garden setting, and you paid one dollar for a highball.

The Castro Revolution was not initially friendly toward music, particularly the rock and roll of the 1960s. Even so, the influence of Cuban music continued. The American folksinger Pete Seger in 1967 performed Joseito Fernandez's orchestration of a poem by the Cuban poet and revolutionary hero José Martí. 'Guantanamera' became an international hit (based on a softer derivative of *son* known as *guajira*). Alas, every Cuban music group in every resort plays what can be a haunting and beautiful ballad to the point of tiresomeness.

Facing page: *Musicians playing in the courtyard of a mansion constructed during the colonial period.*

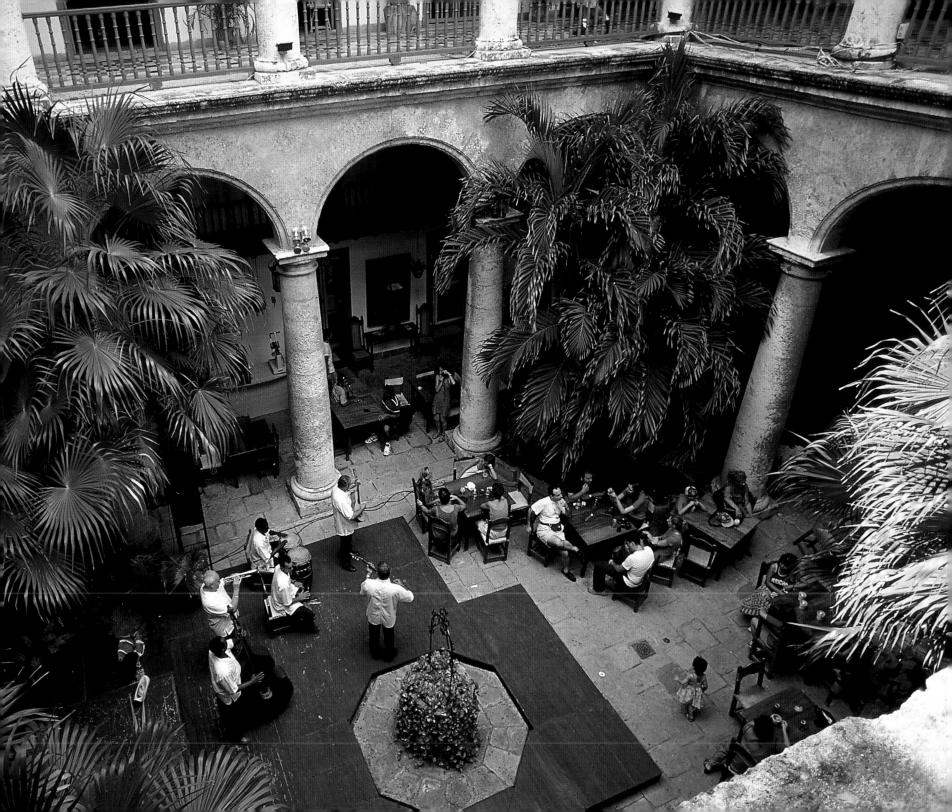

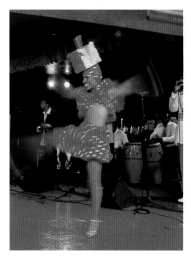

The National Cabaret in Havana.

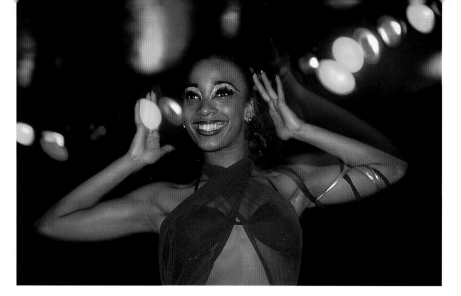

A singer in the National Cabaret show in Havana.

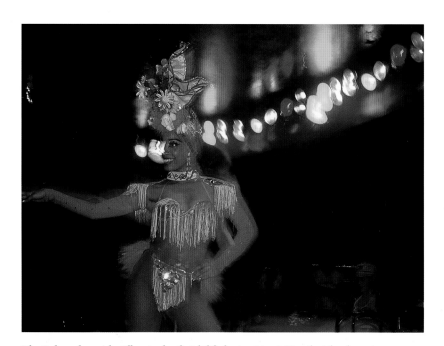

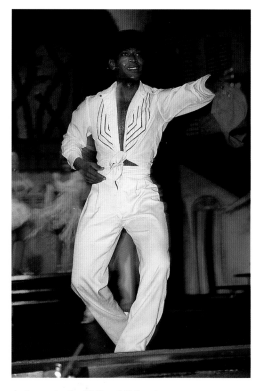

The Cuban showgirl, still a staple of nightlife for tourists visiting the island.

A dancer in the National Cabaret.

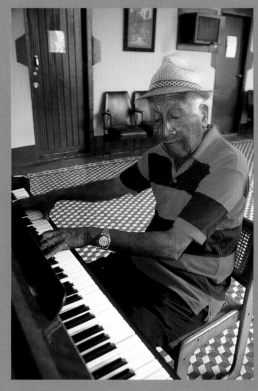

Pepecito Reyes, still going strong in his early eighties. He is another one of Santiago's recently re-discovered musical gems.

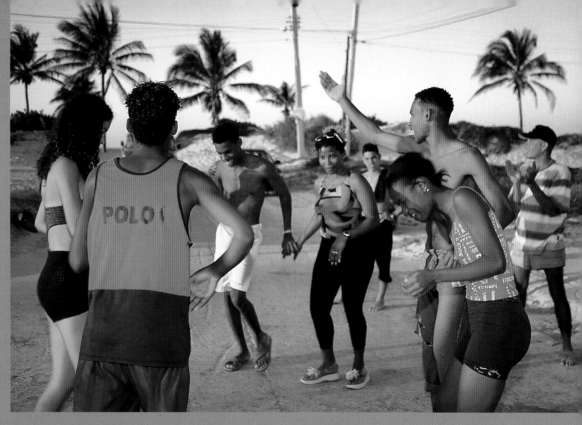

In the village of Guanabo, you dance in the streets.

Timba is but the latest sensation to sweep the island. Personified by the popular local group Los Van Van, it's a mishmash of everything from Brazilian to salsa to hip-hop. Fidel himself has shown enthusiasm for, of all things, hip-hop. He told a group of hip-hop artists not long ago that he knows all about rap. So far he remains the only head of state in the world to have made such an admission.

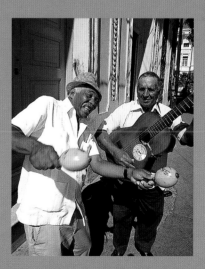

Street musicians in Santiago de Cuba.

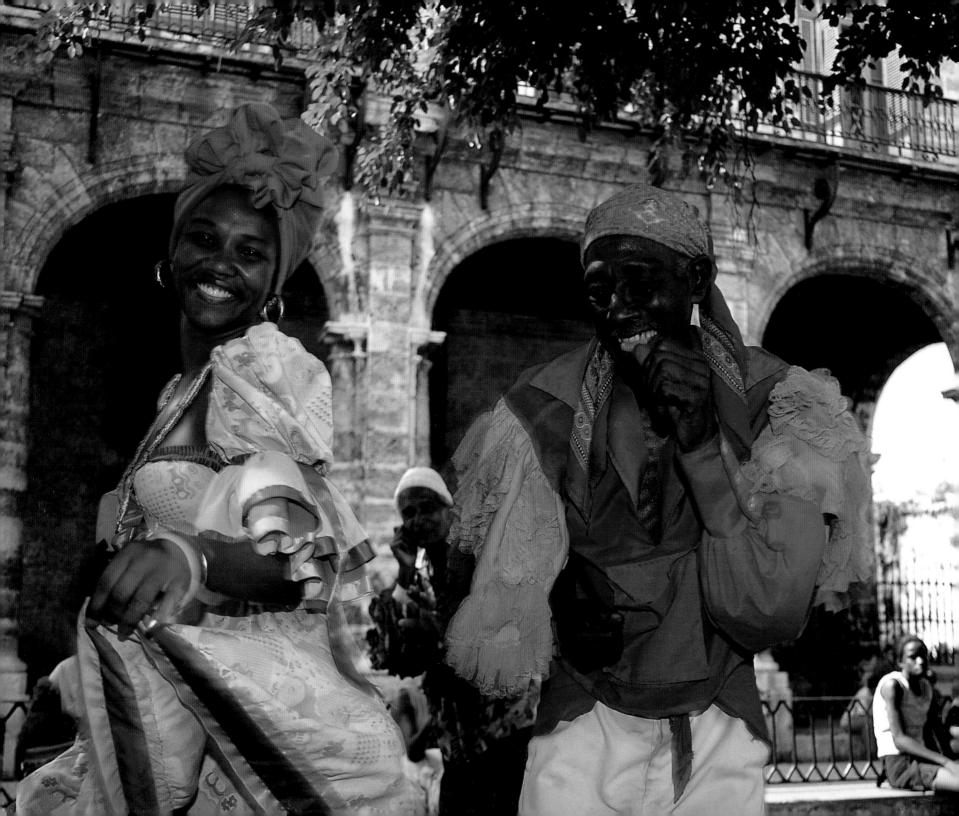